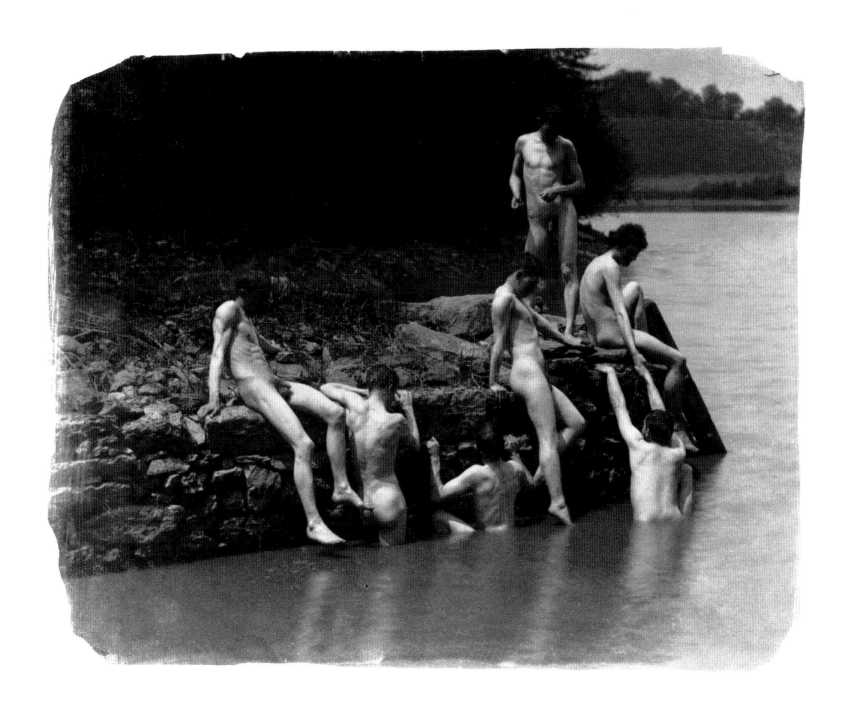

2

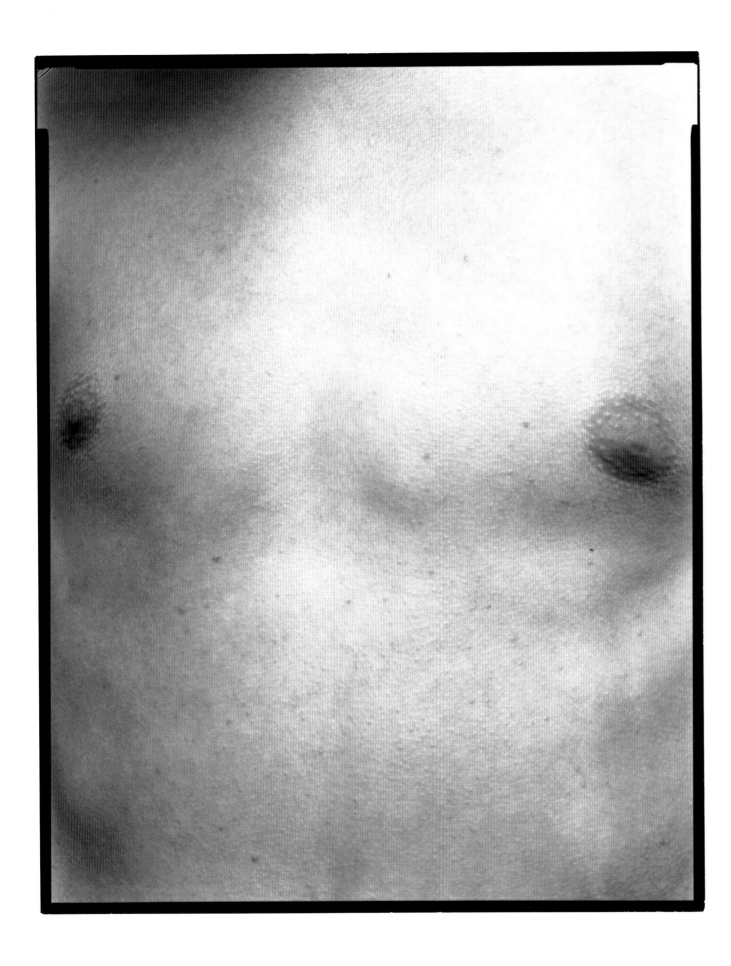

3

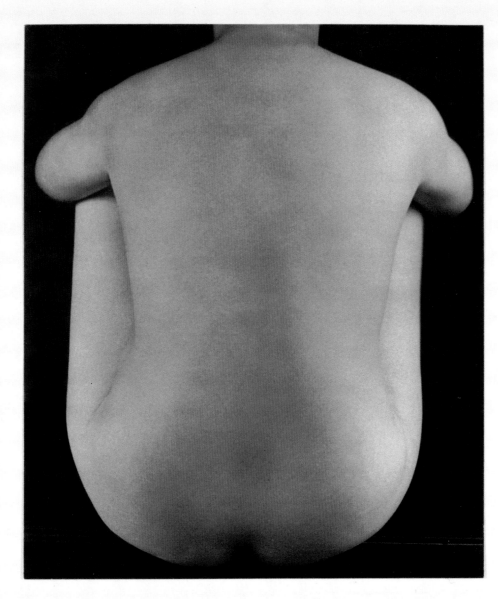

Edward Weston
Mexico 1925

5

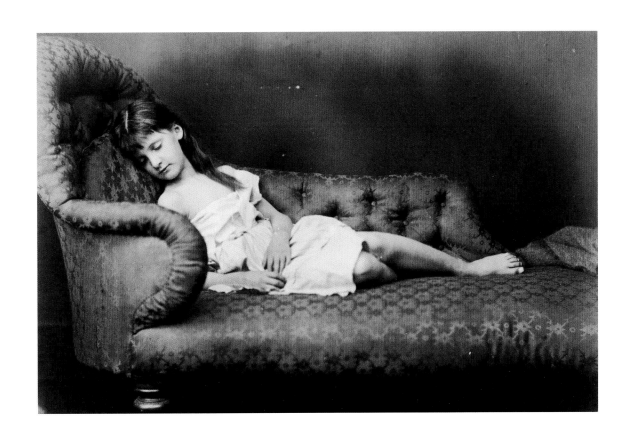

6

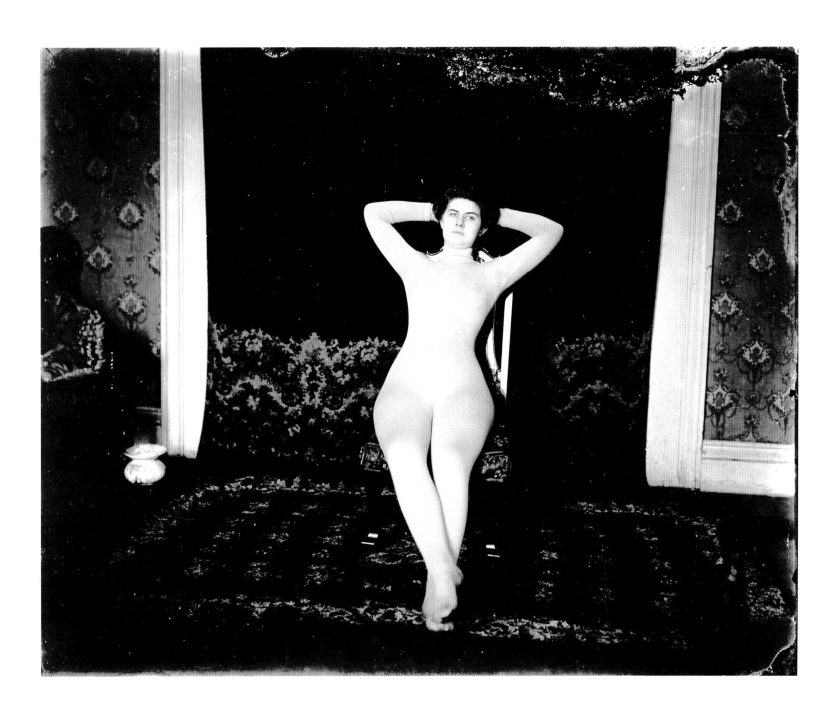

7

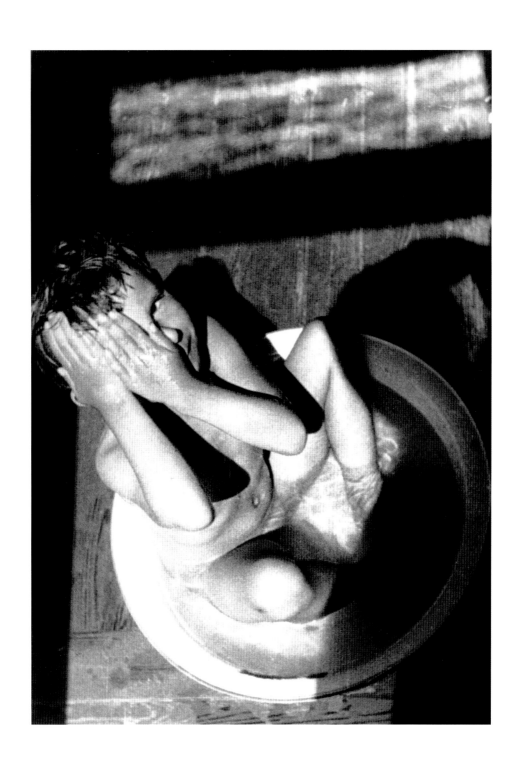

8

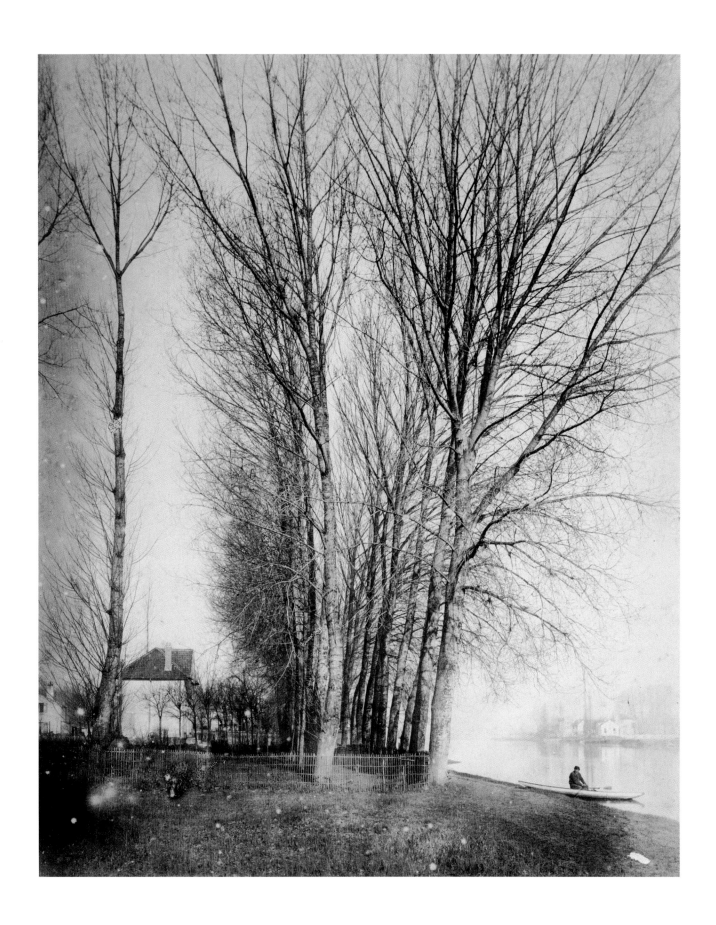

9

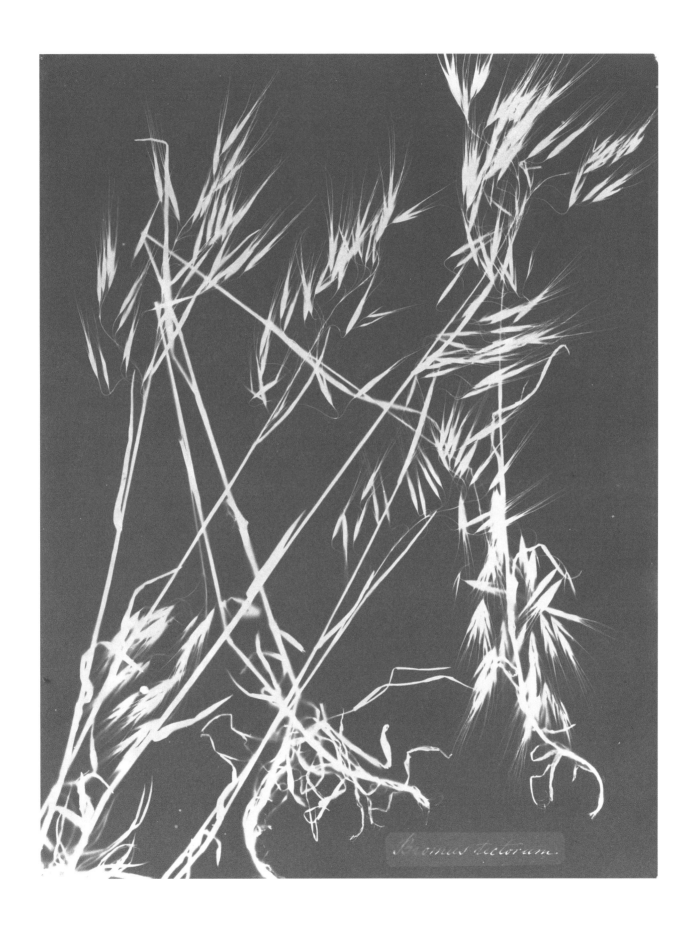

Bromus tectorum.

10

11

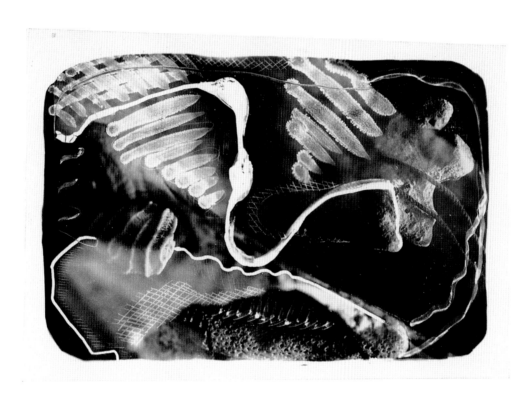

12

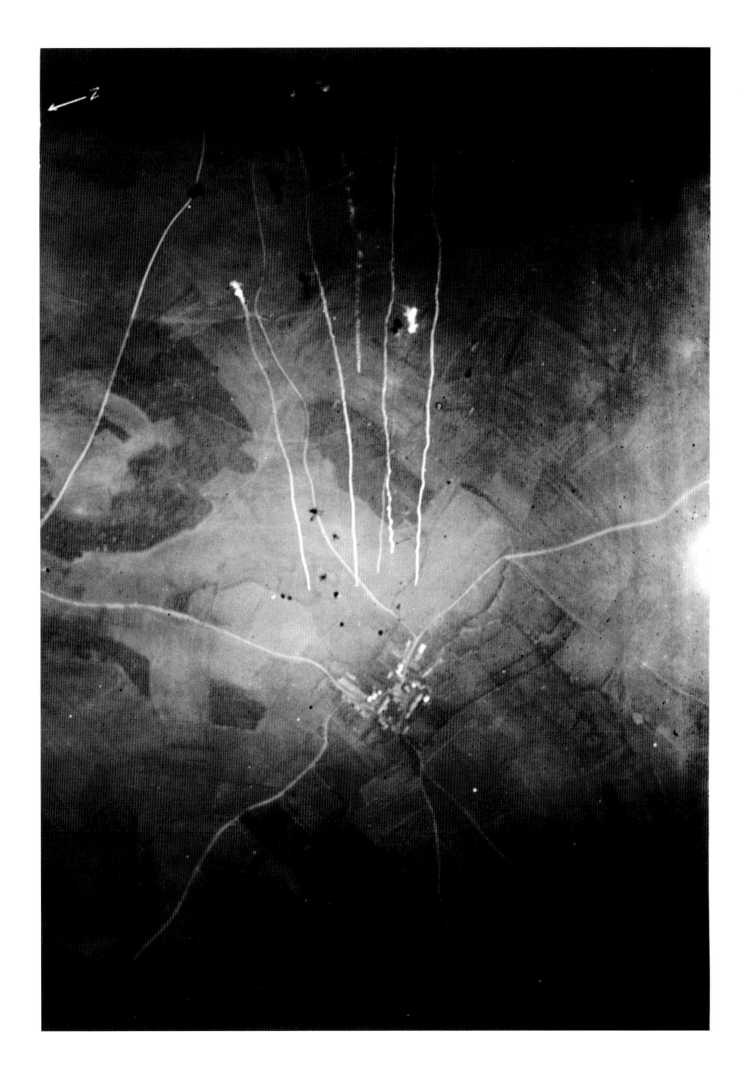

13

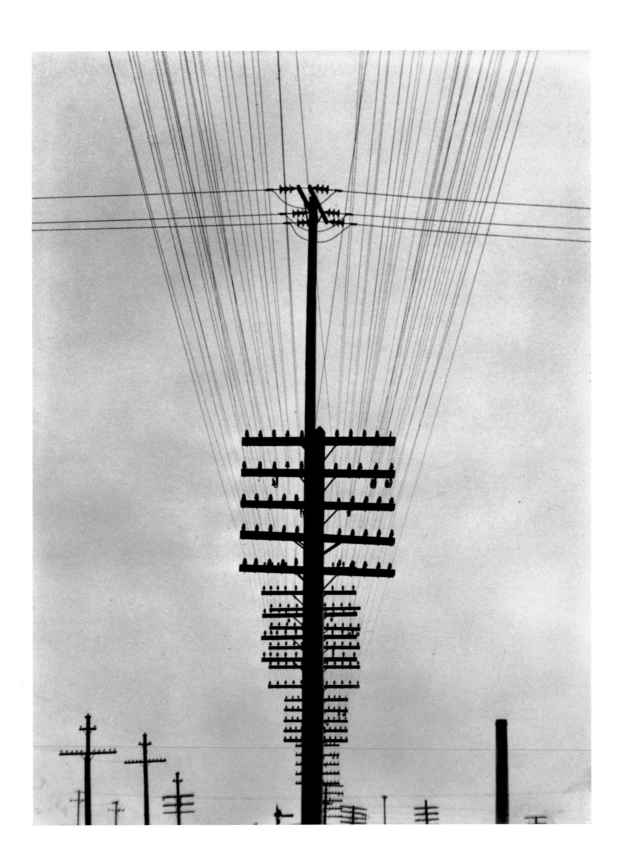

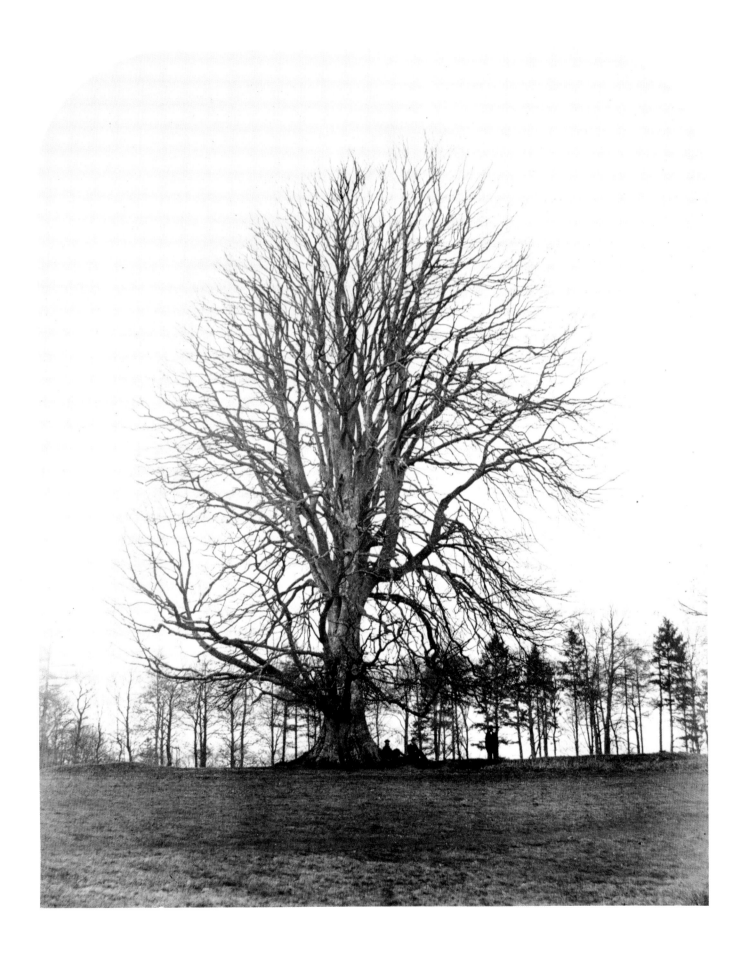

15

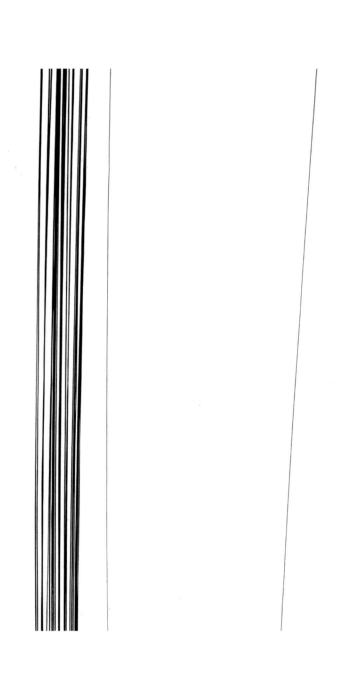

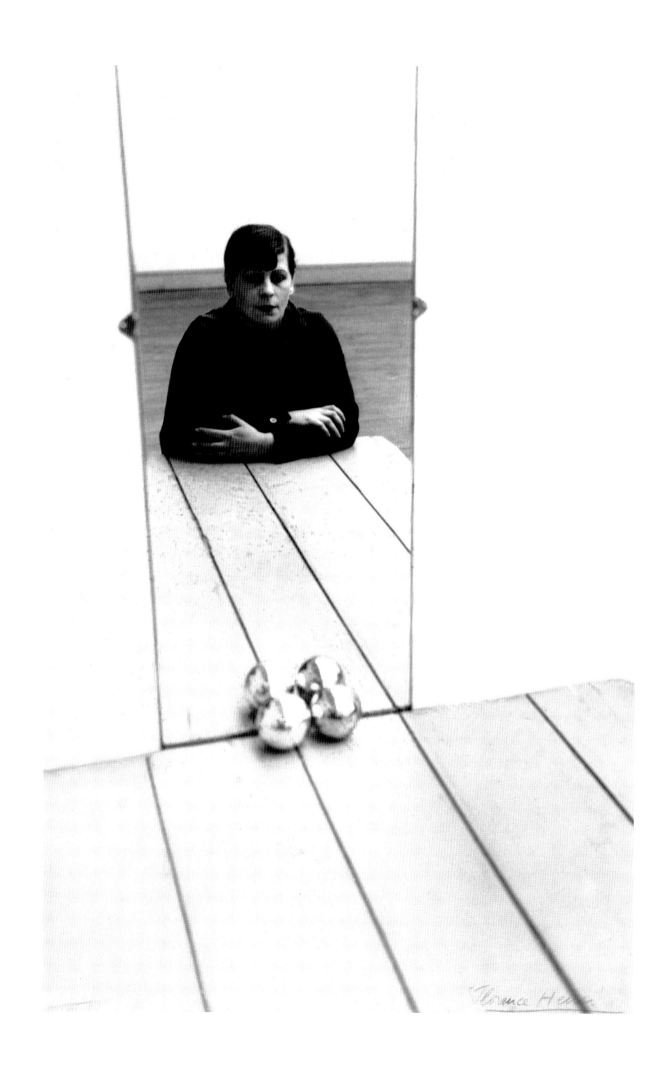

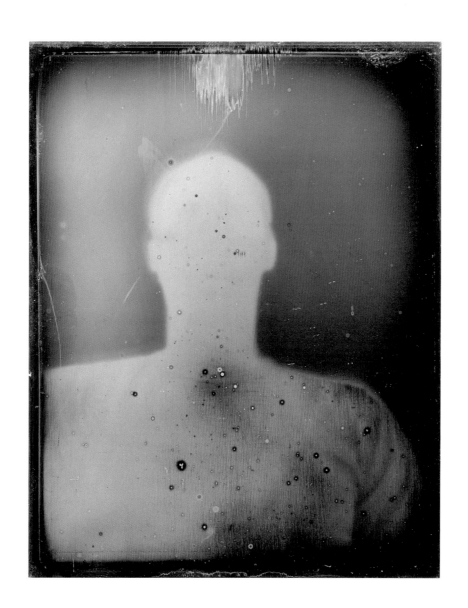

19

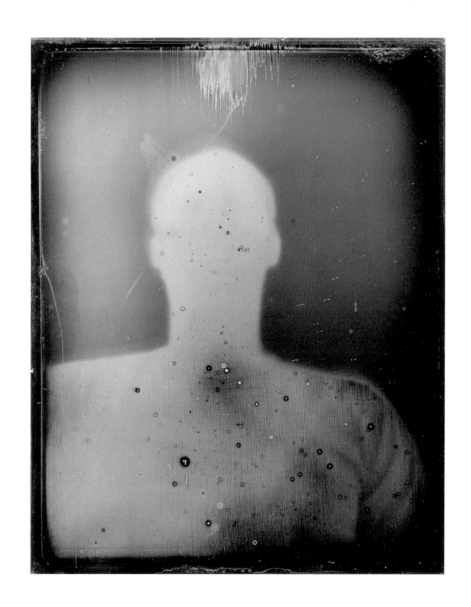

18

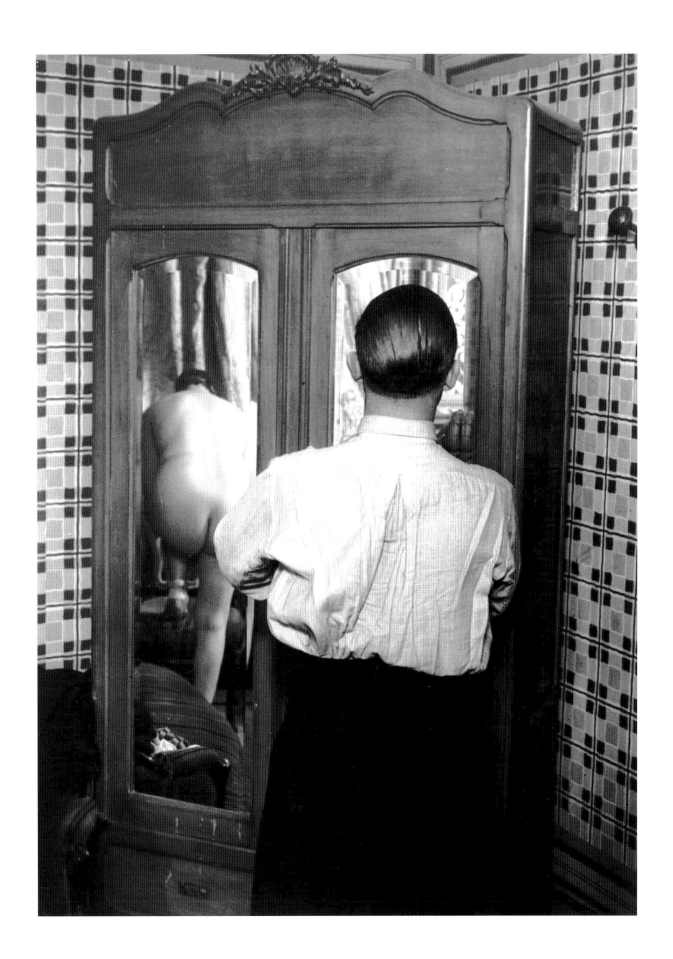

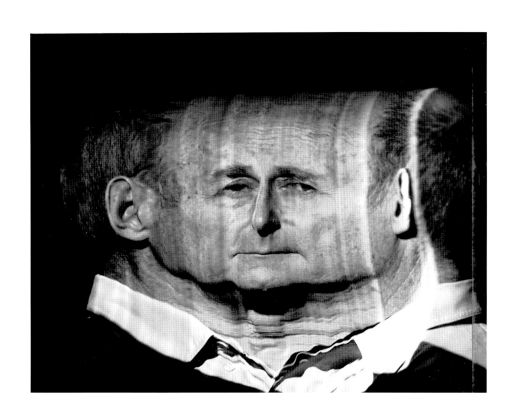

20

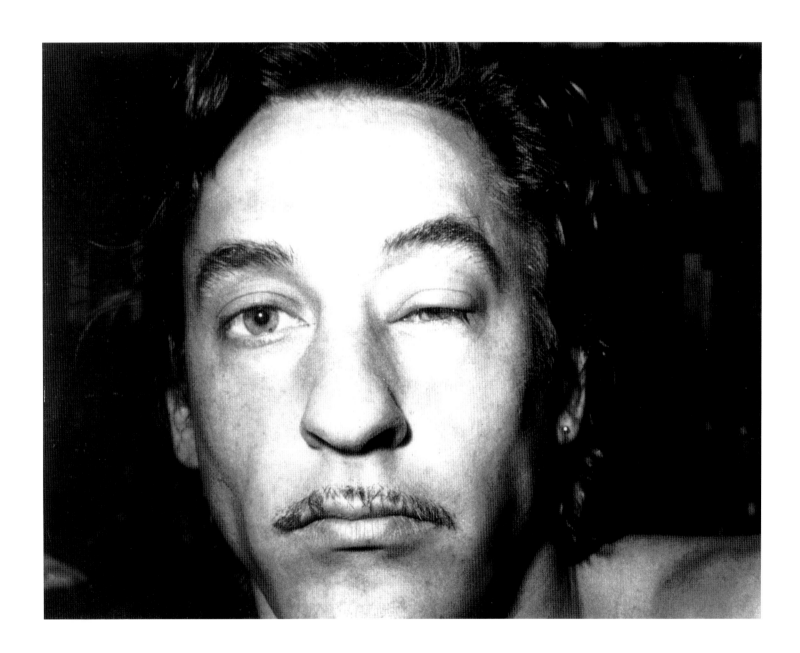

21

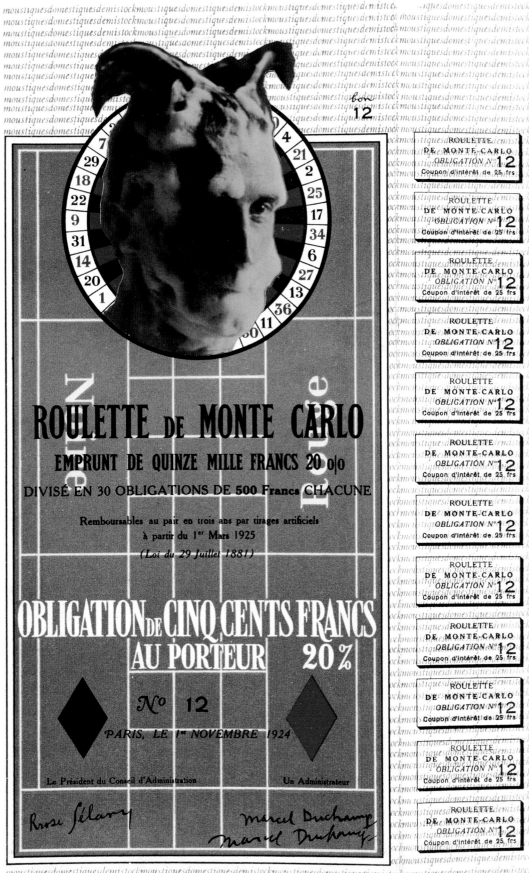

22

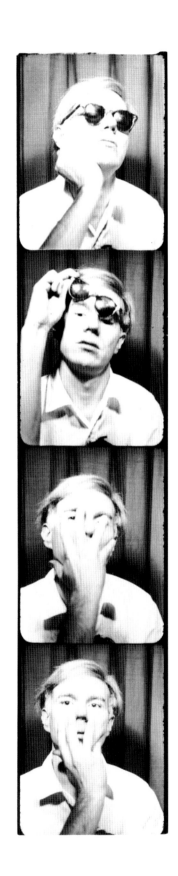

23

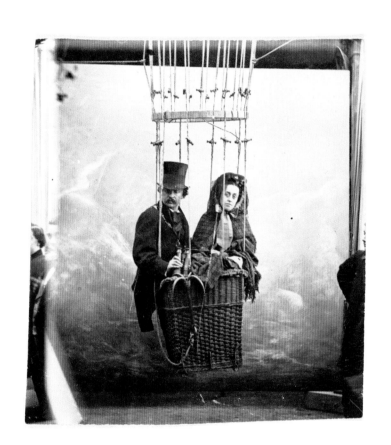

24

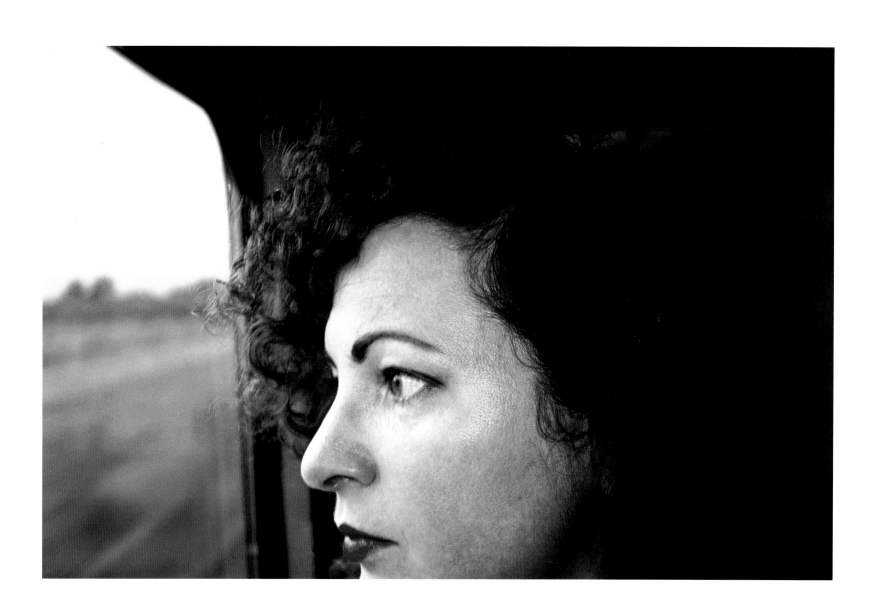

25

Rogues Gallery

Emotional moments; remarkable
dramatics and facial contortionisms

Take it away

Don't tell me
your troubles
I'm not the chaplain

I can't stand
it. I can't stand
it.

Come here I
want to talk to
you

Please go away

Don't you get
it? (I just told a joke)

nice teeth

Listening

"Hedy" don't you think

27

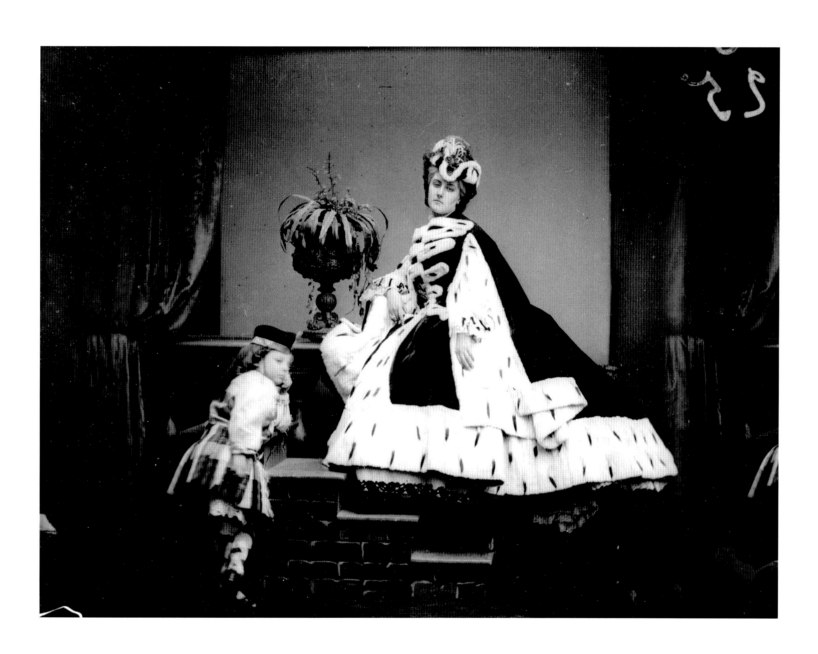

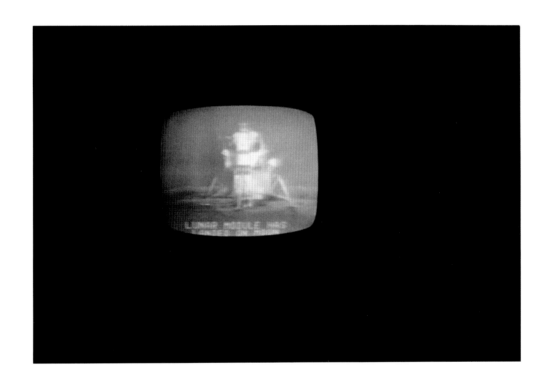

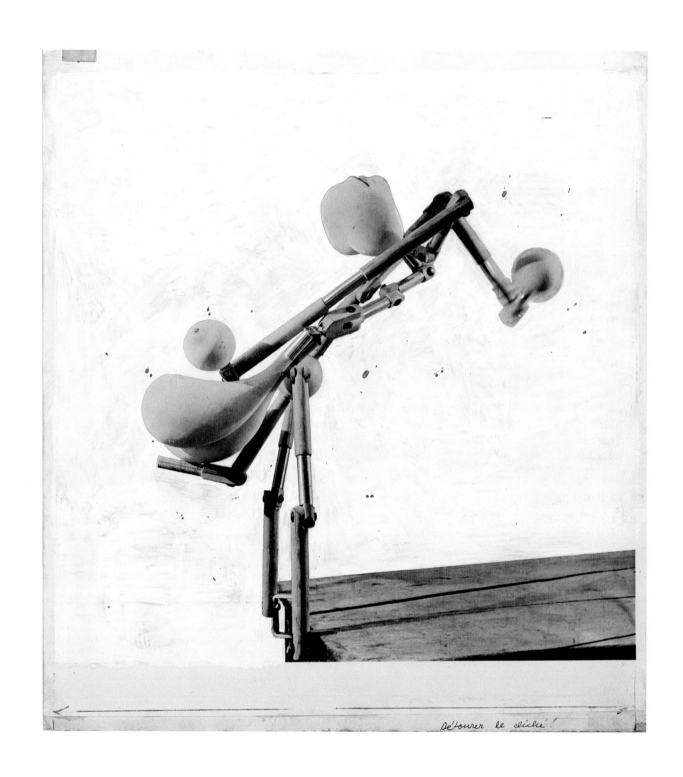

Détourner le cliché !

29 a,b,c

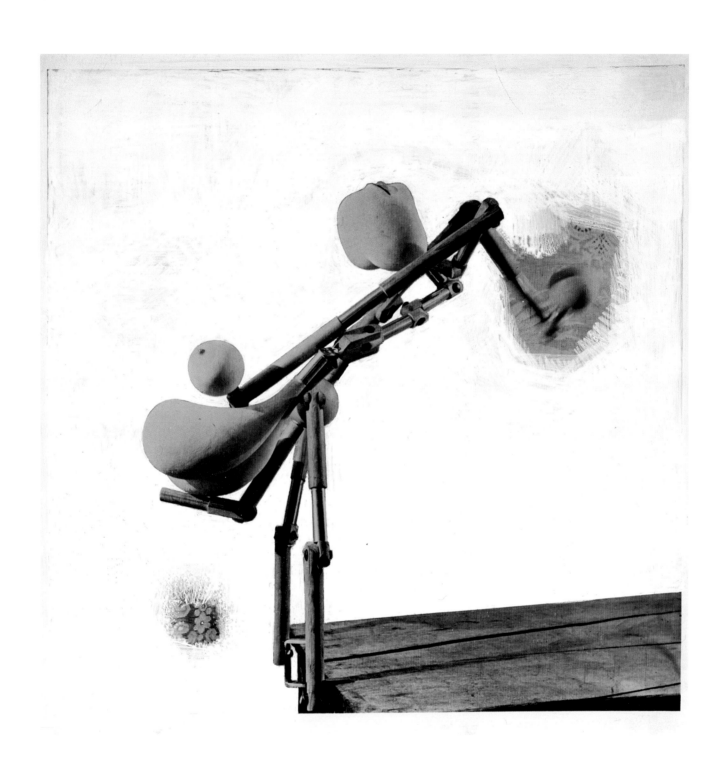

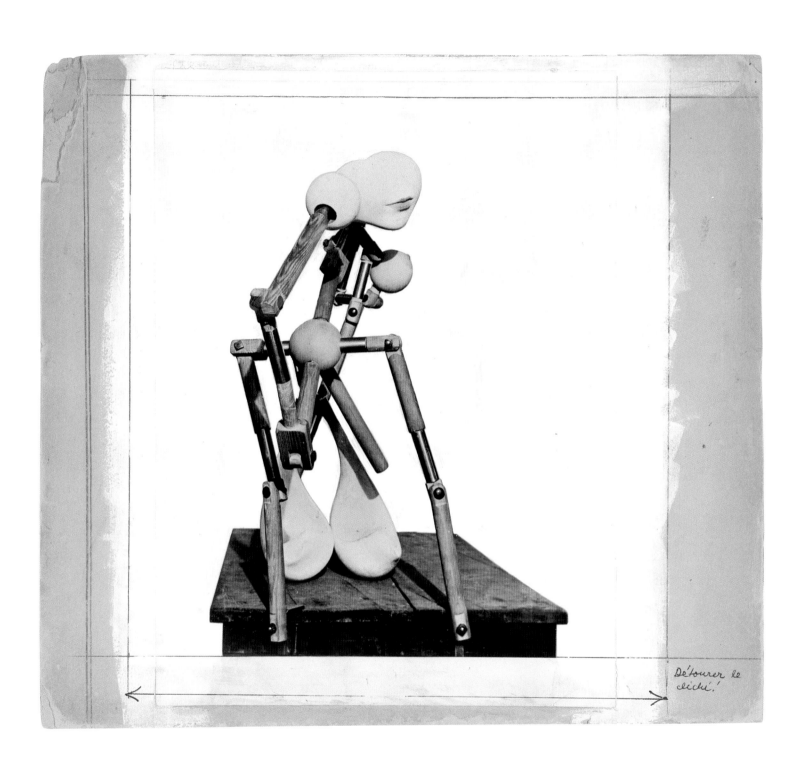

Détourer le
cliché.

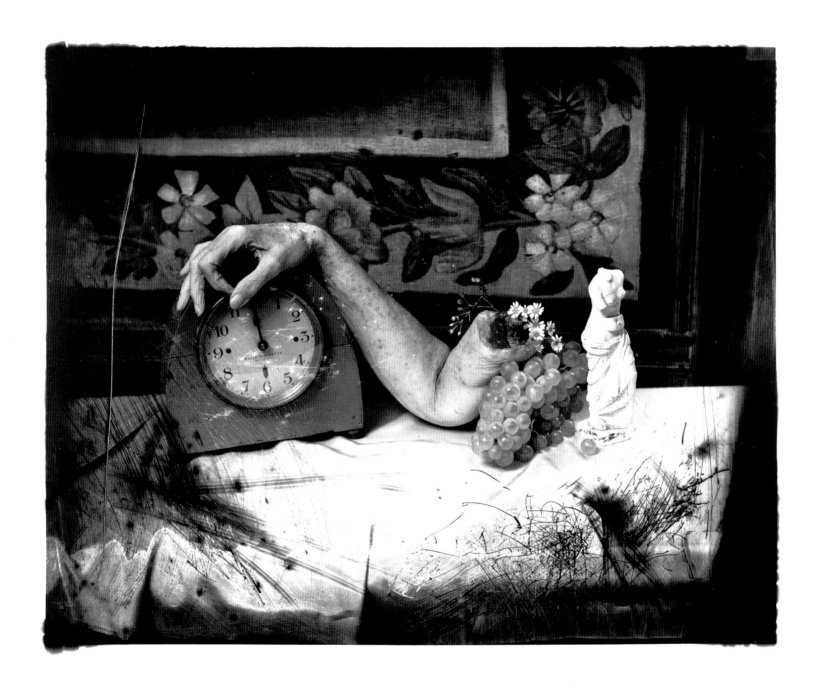

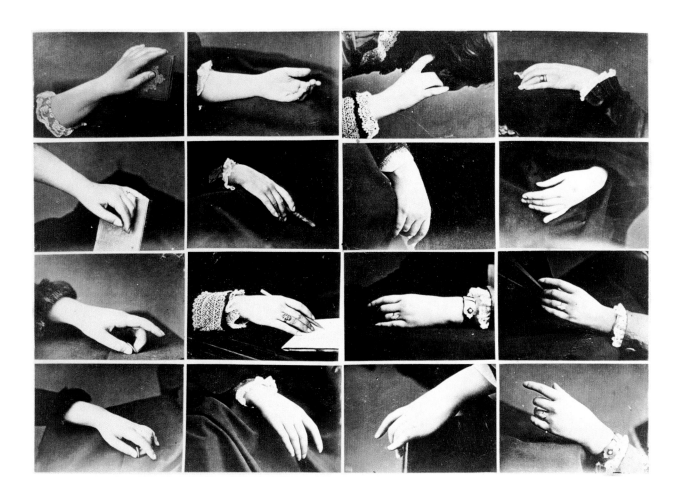

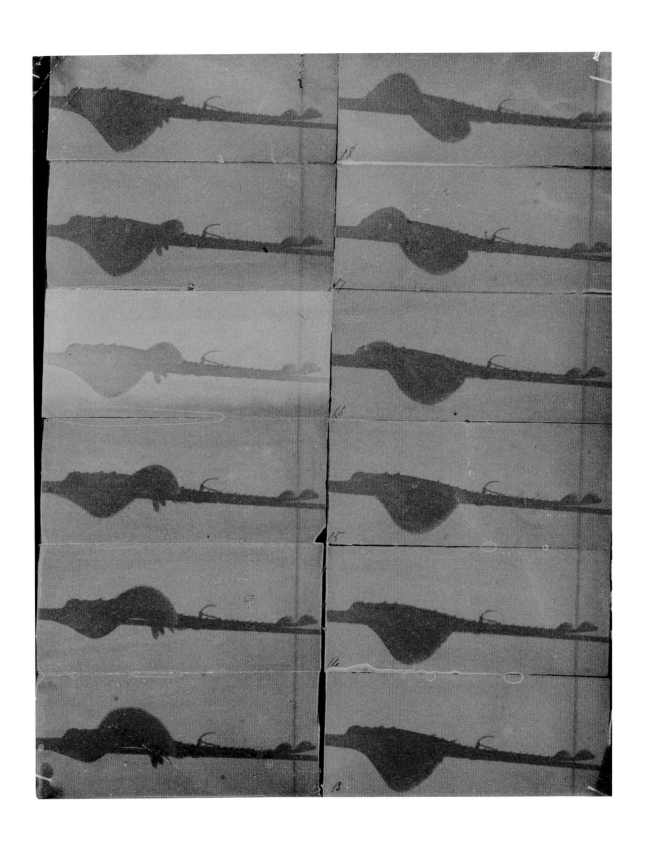

33

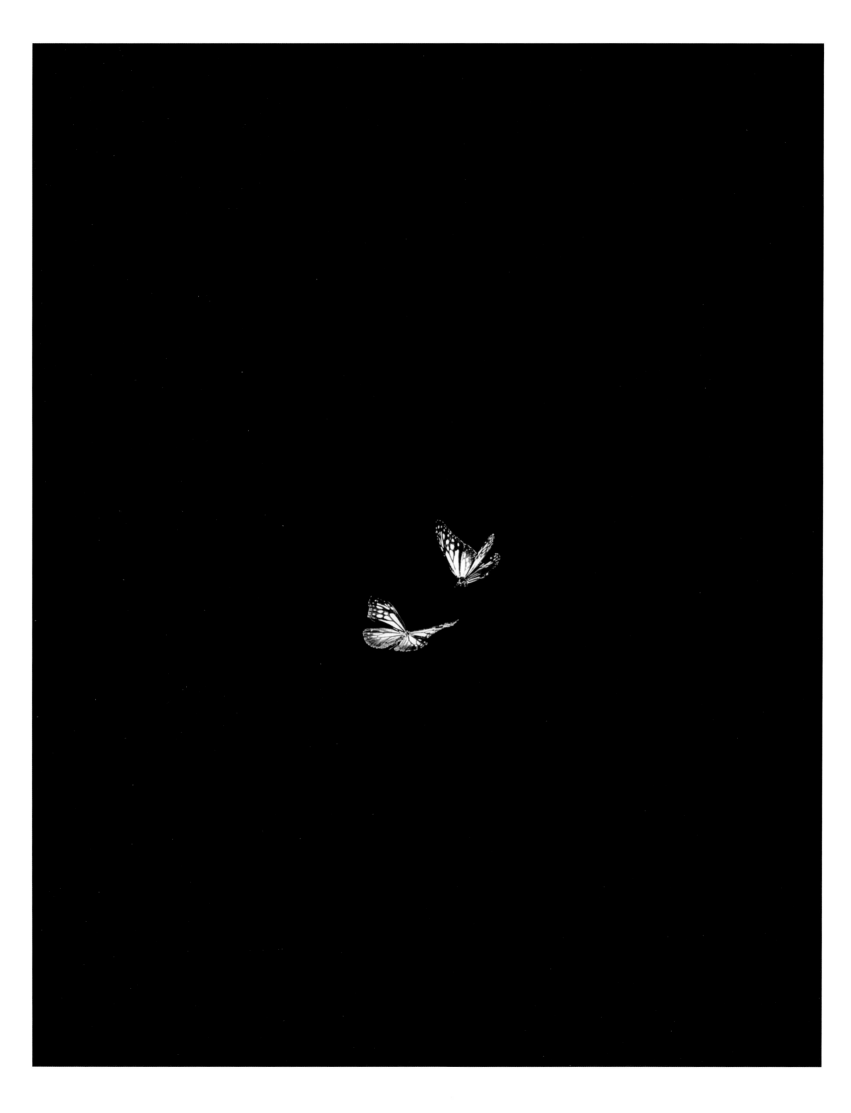

34

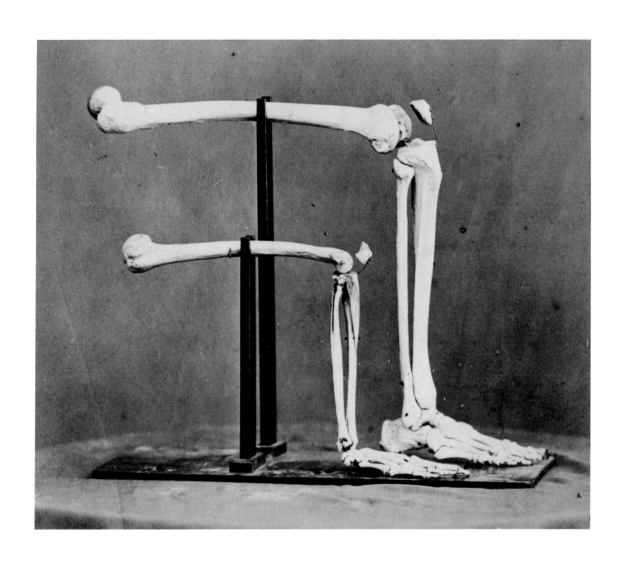

35

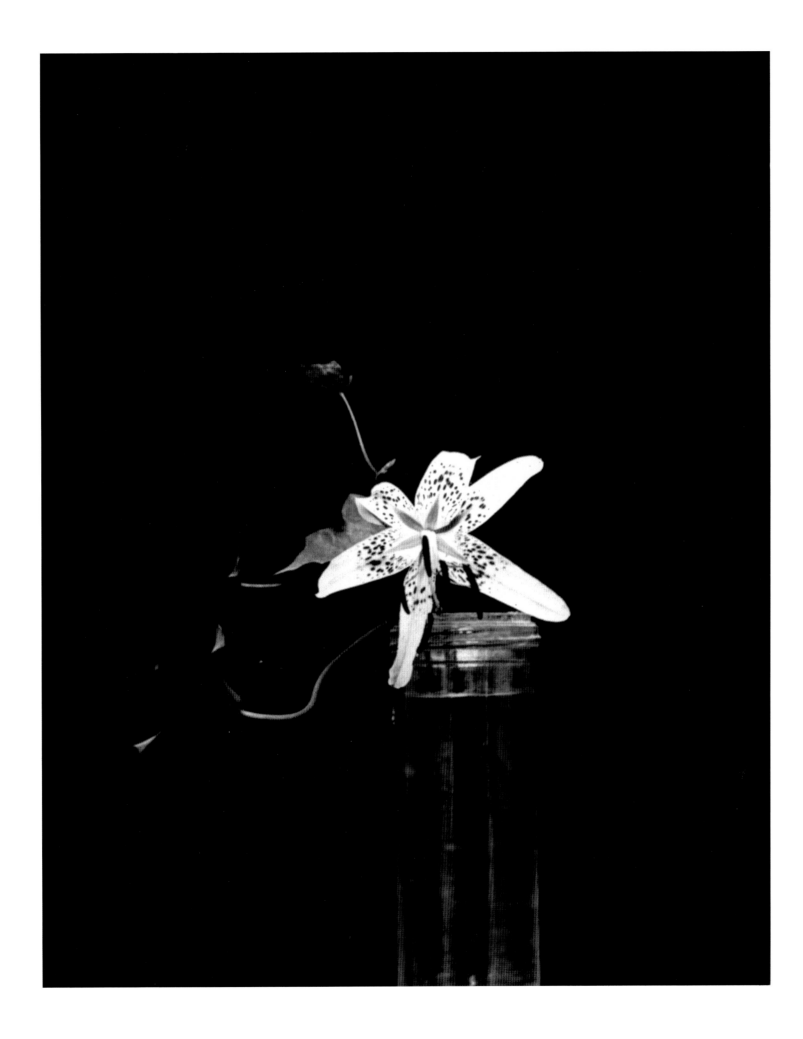

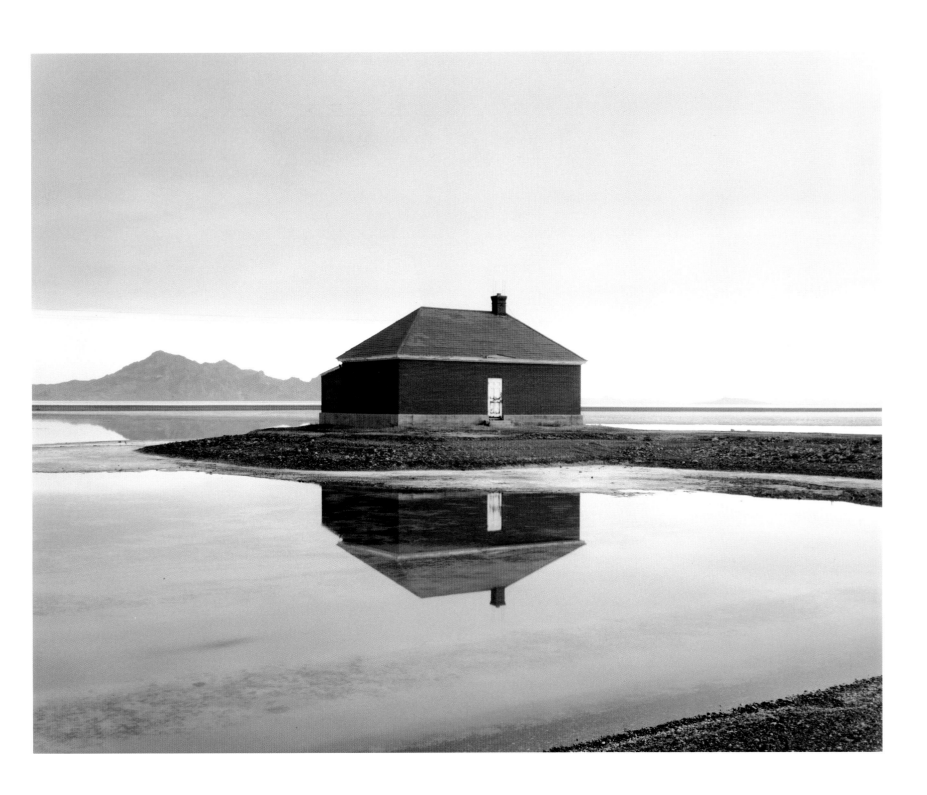

37

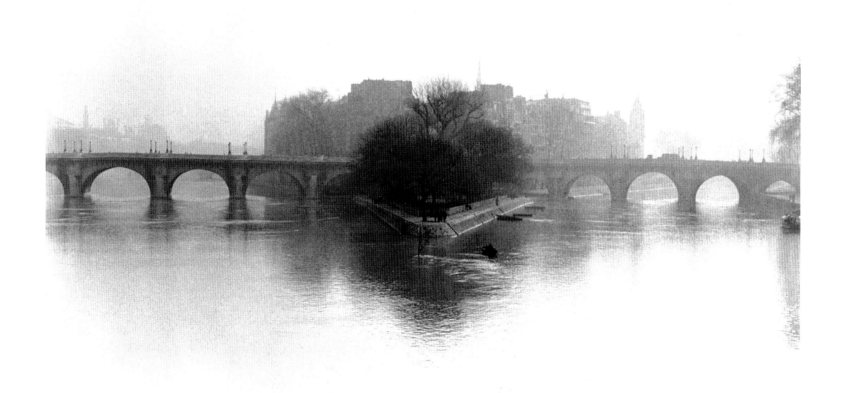

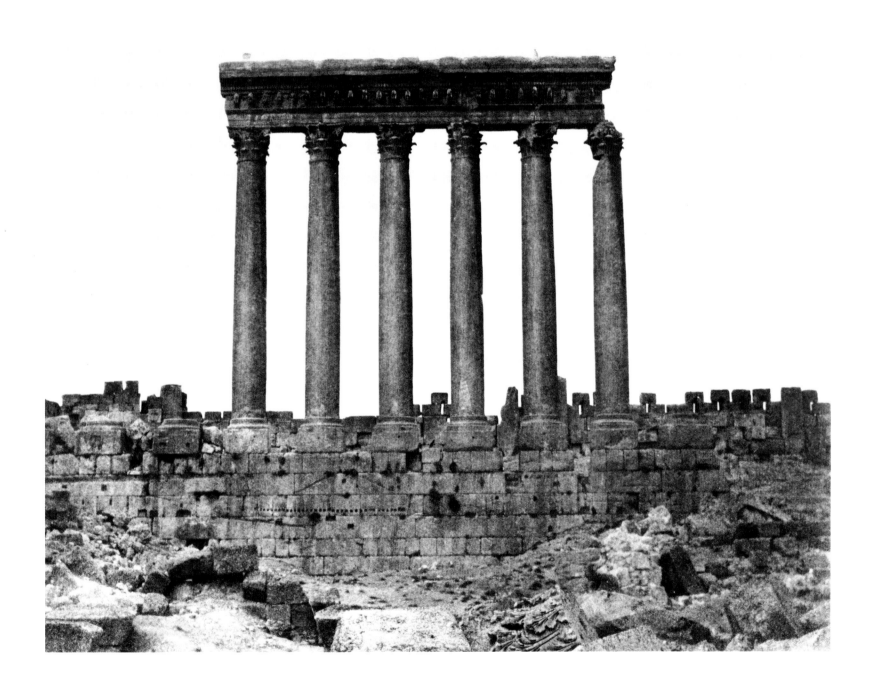

39

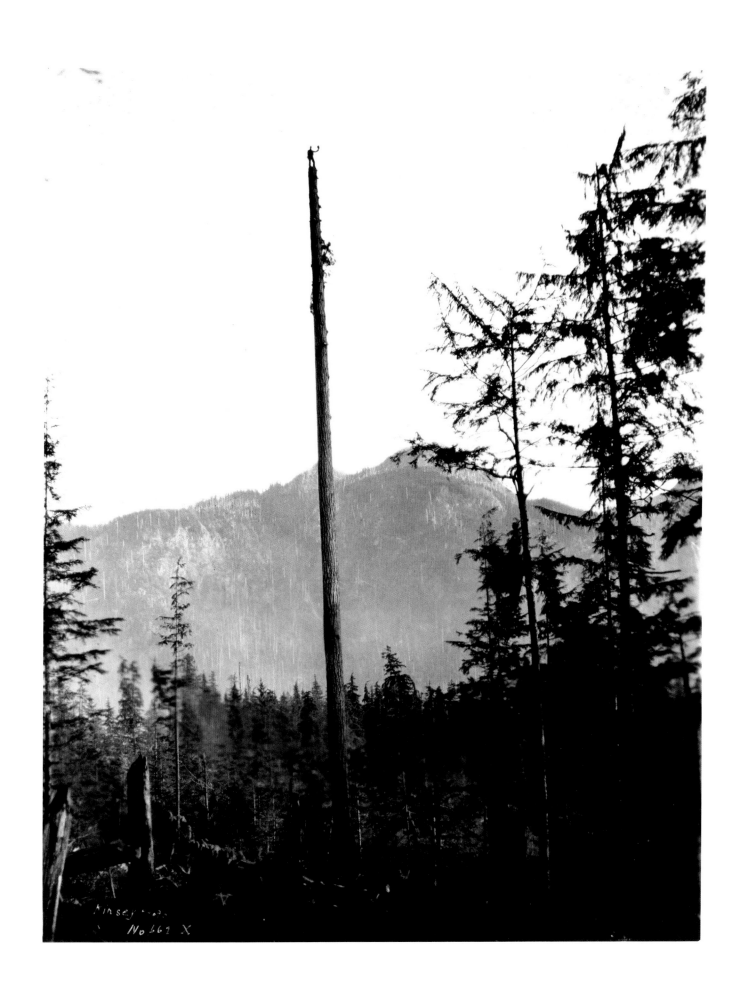

40

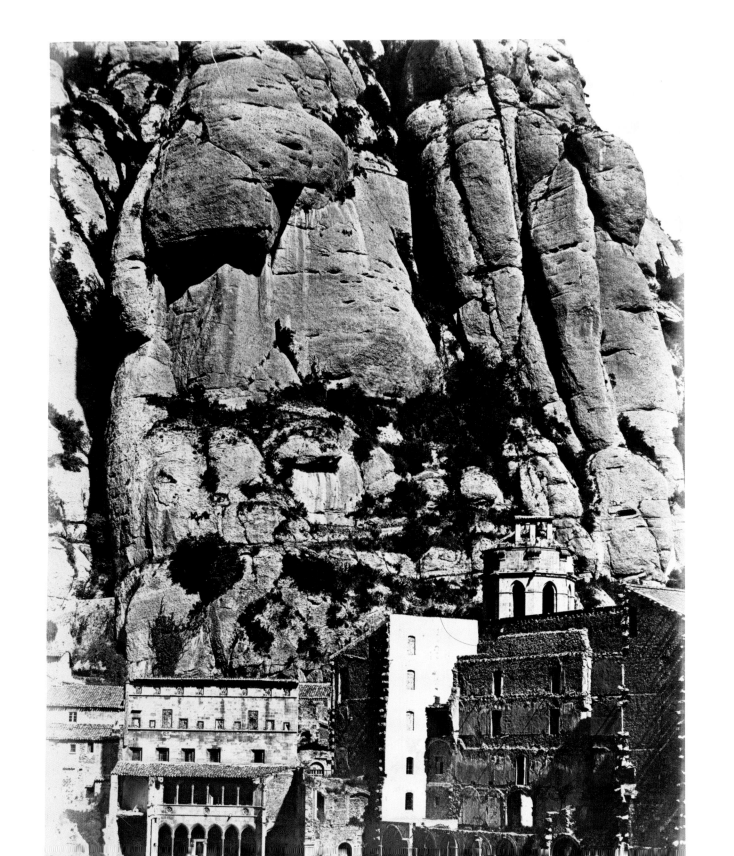

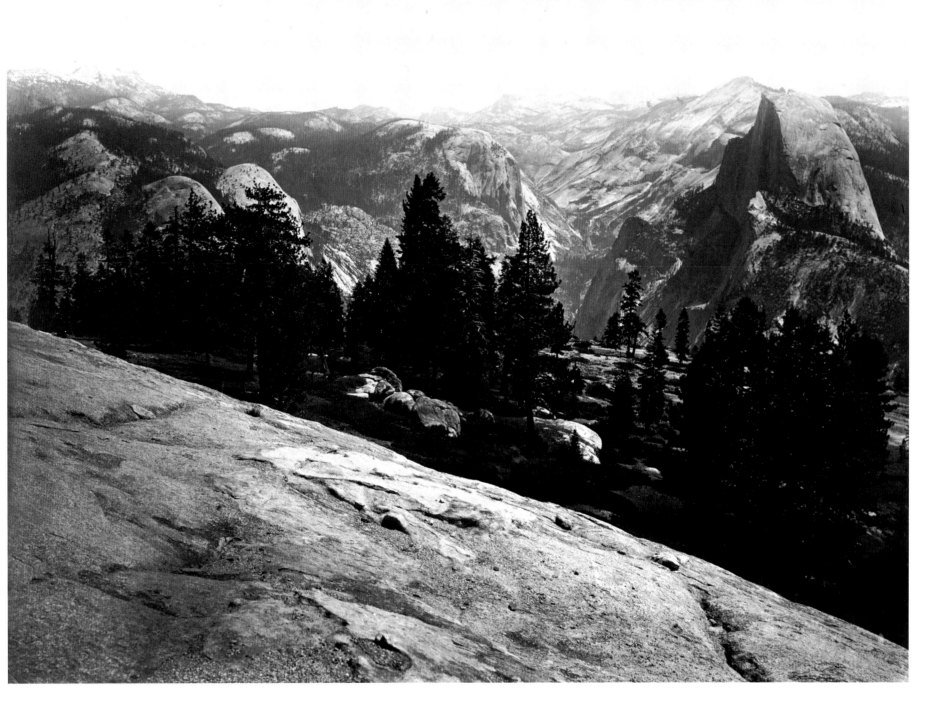

43

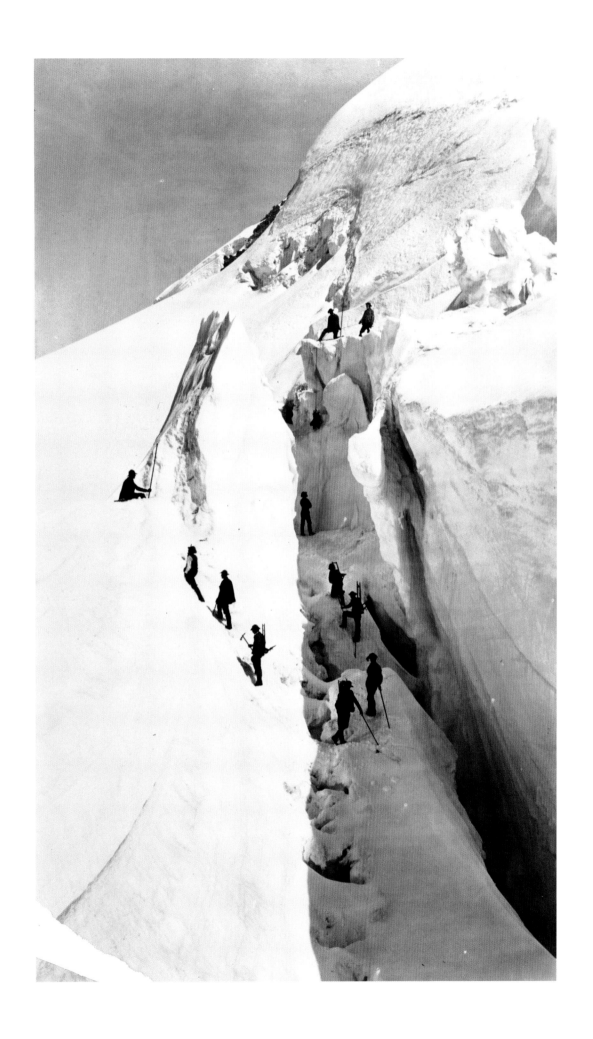

44

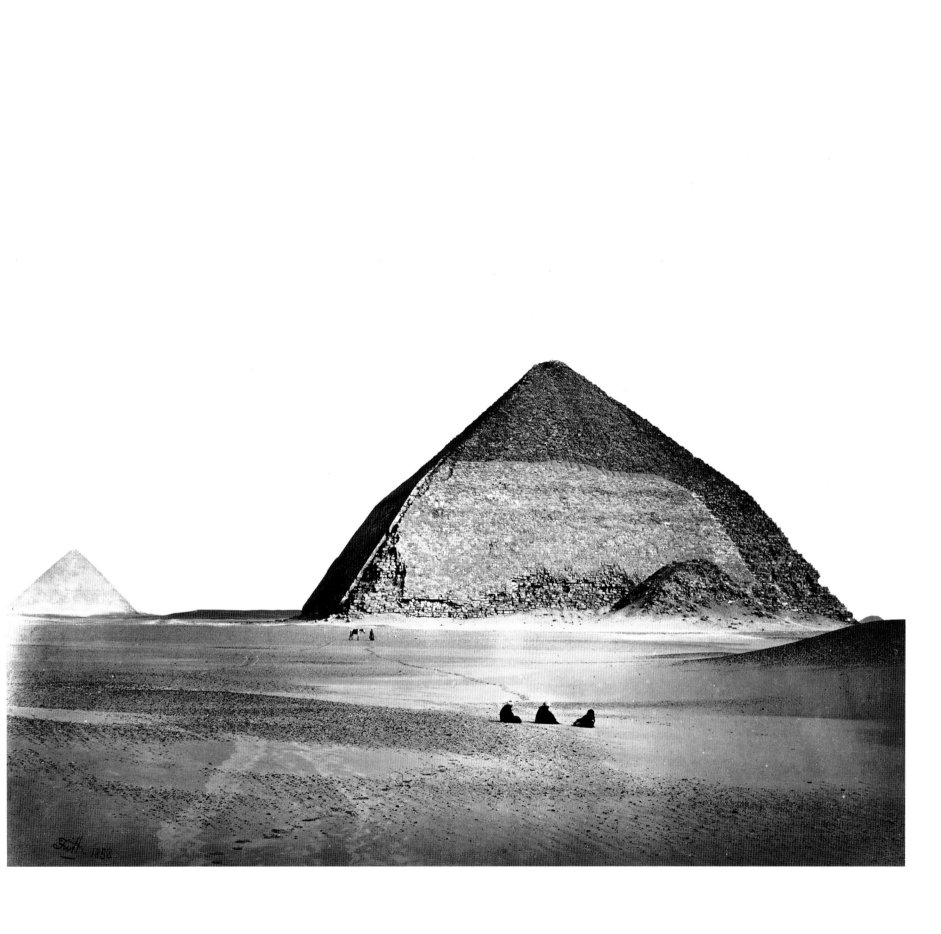

45

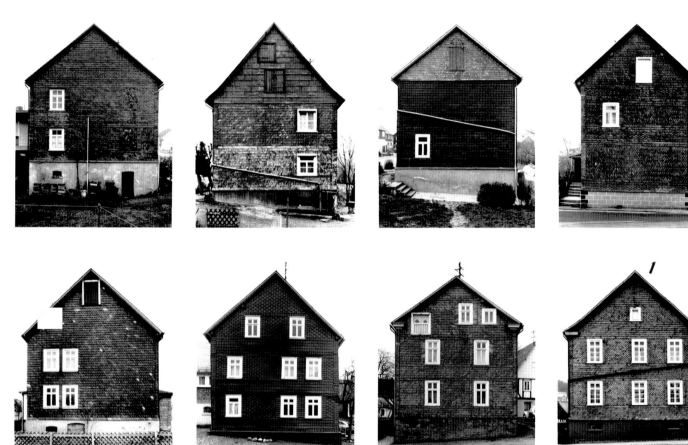

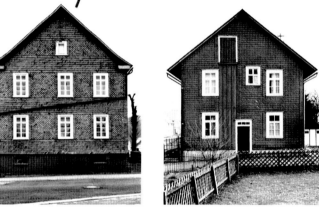

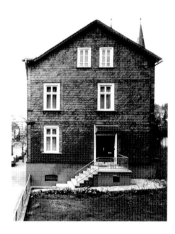

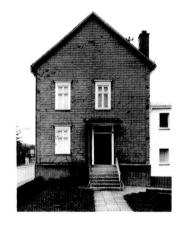

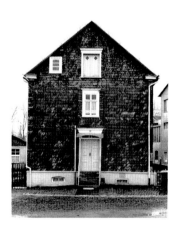

46

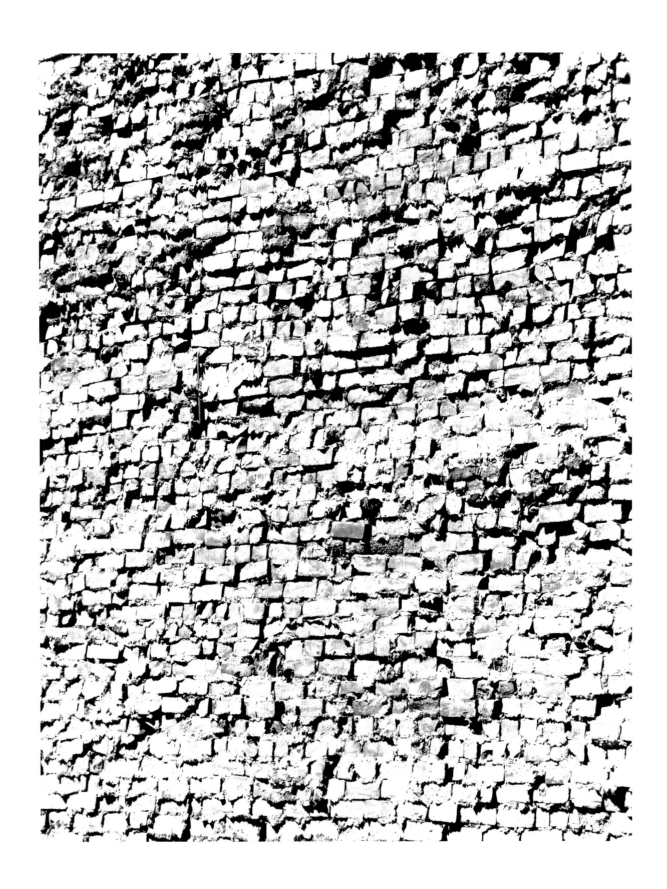

47

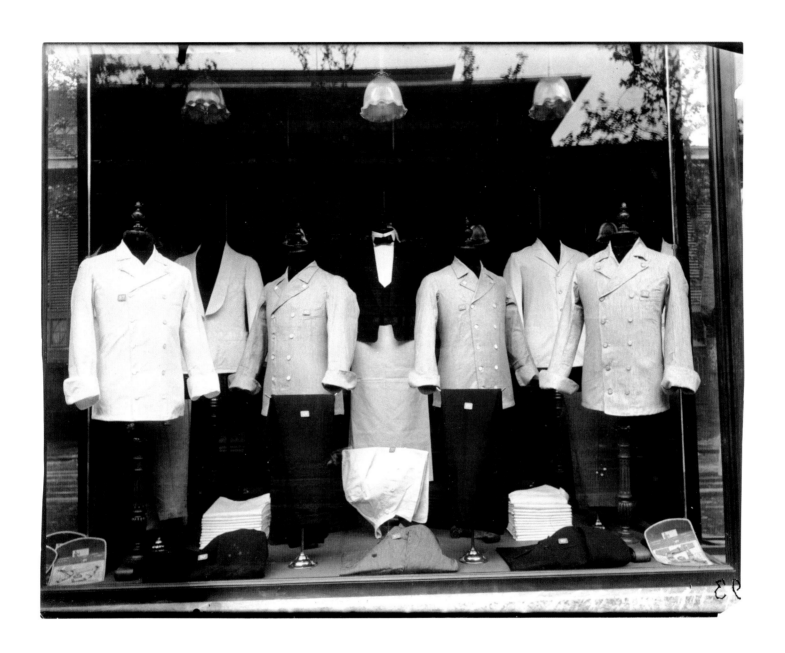

48

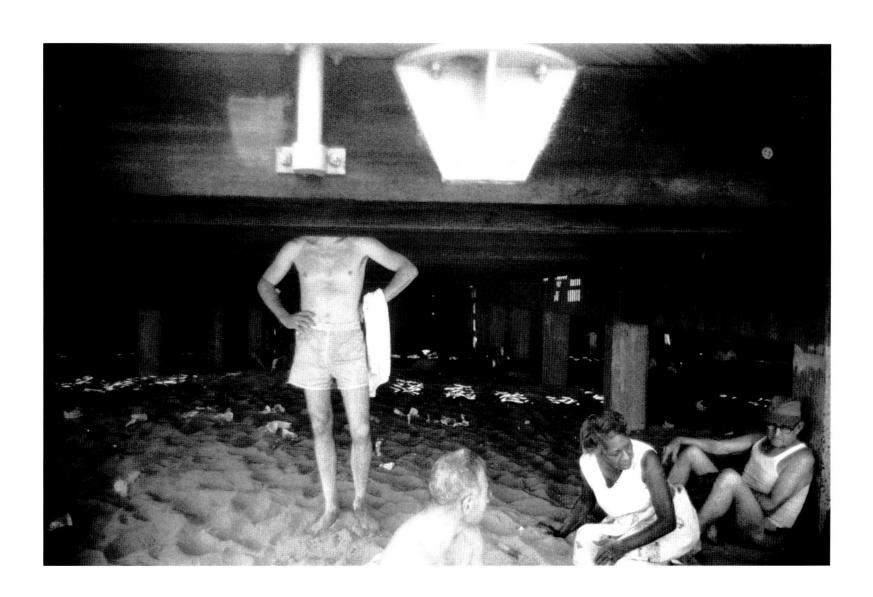

49

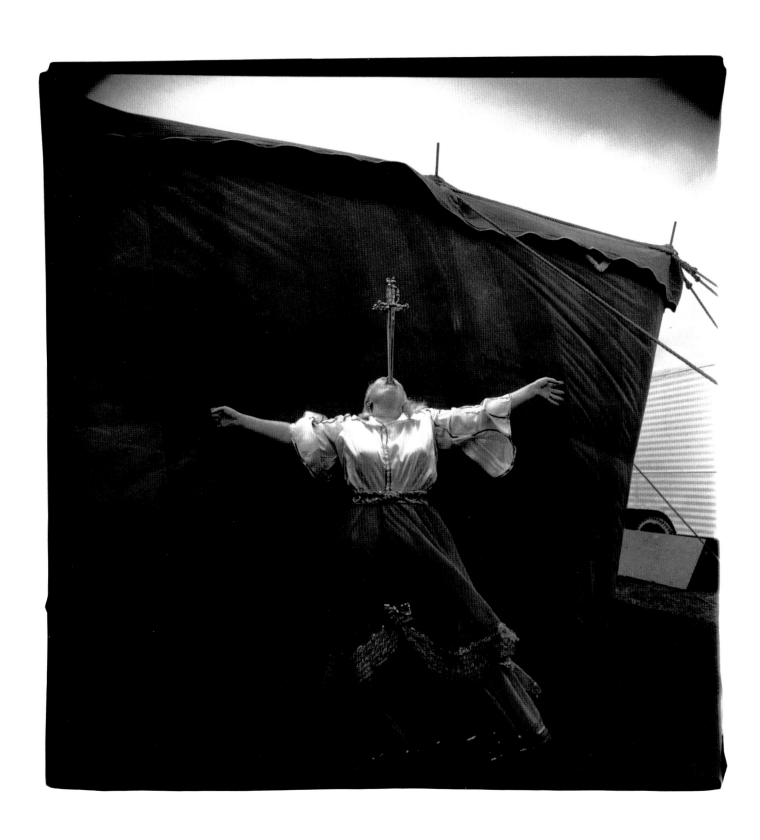

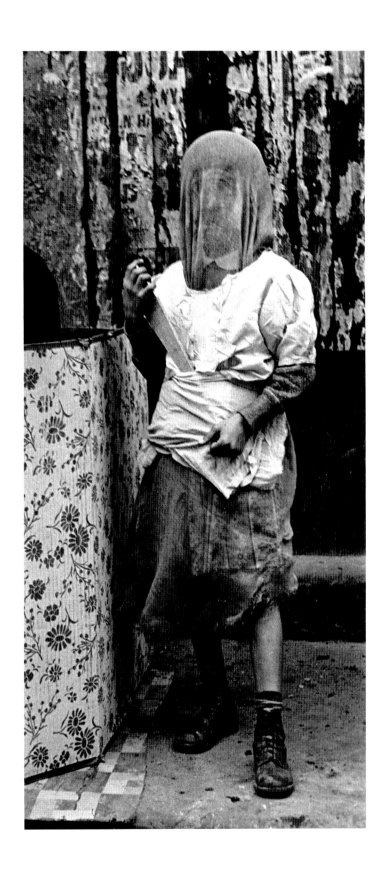

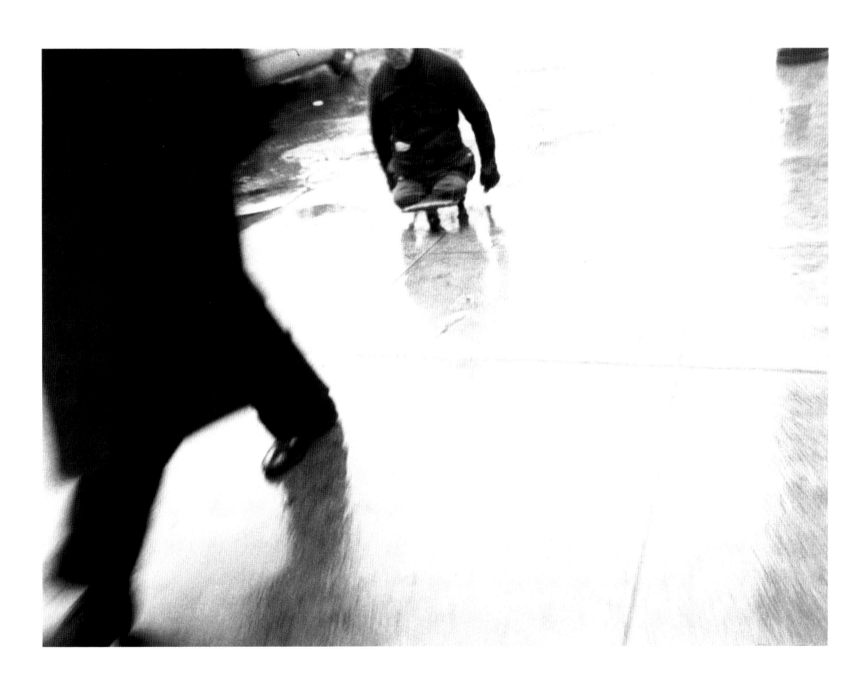

52

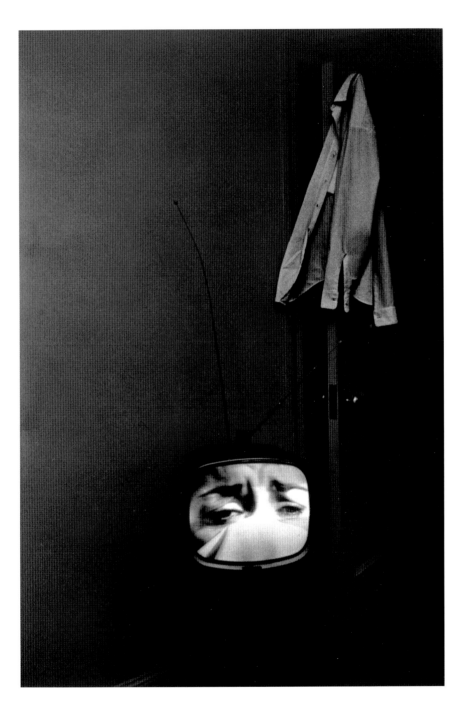
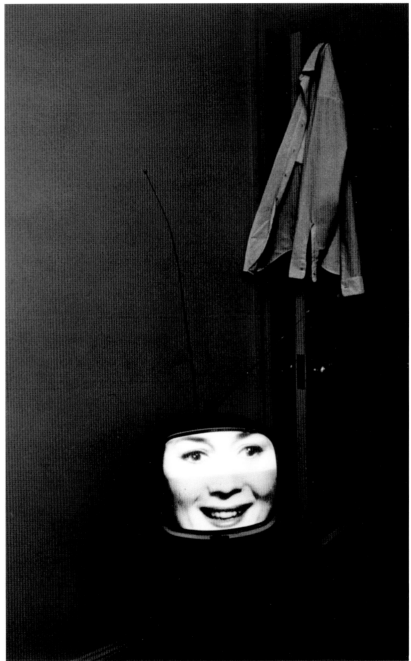

53

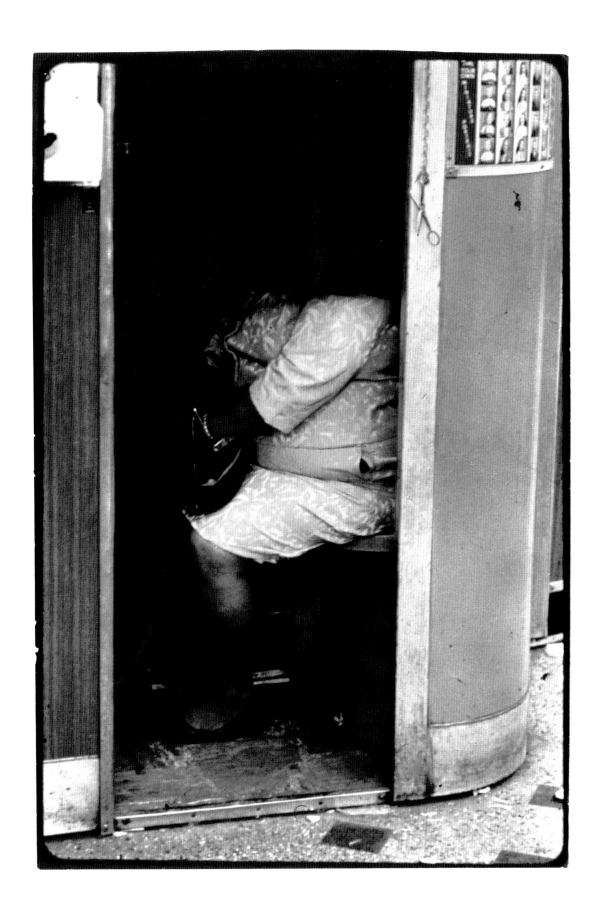

54

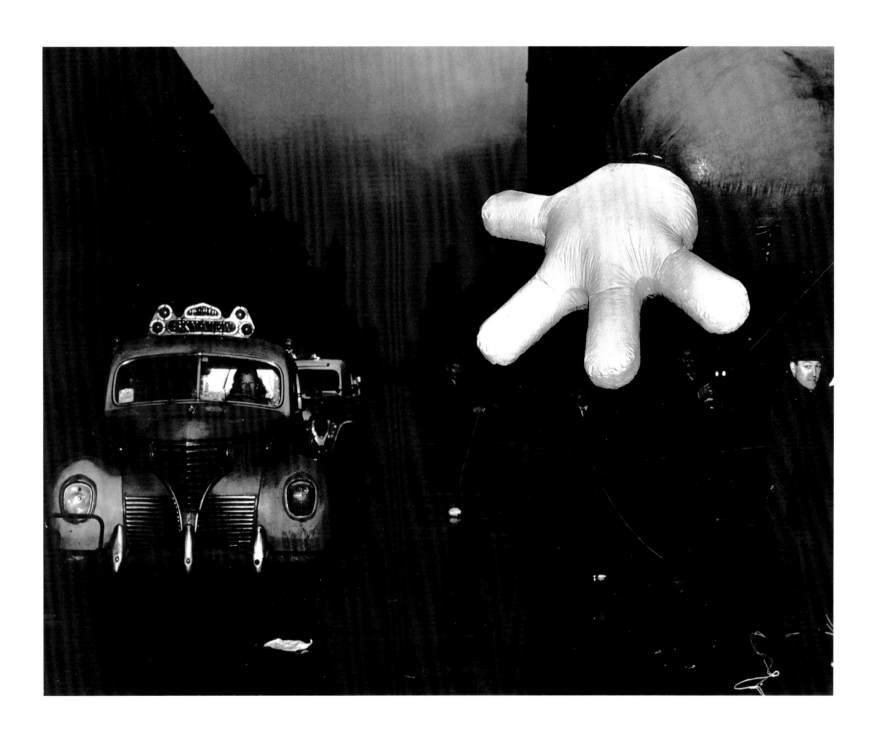

55

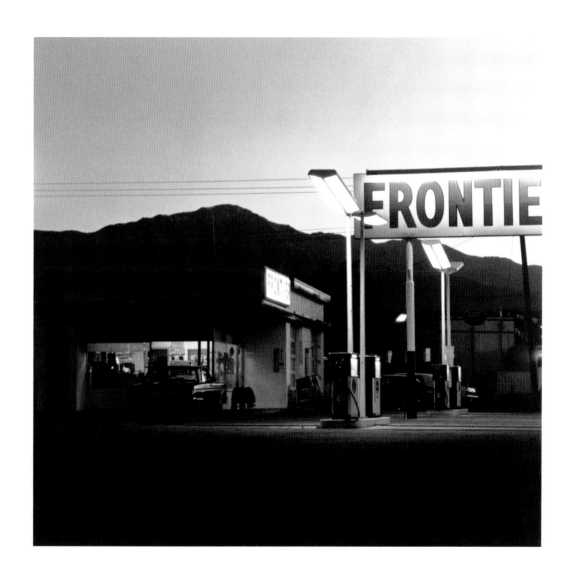

56

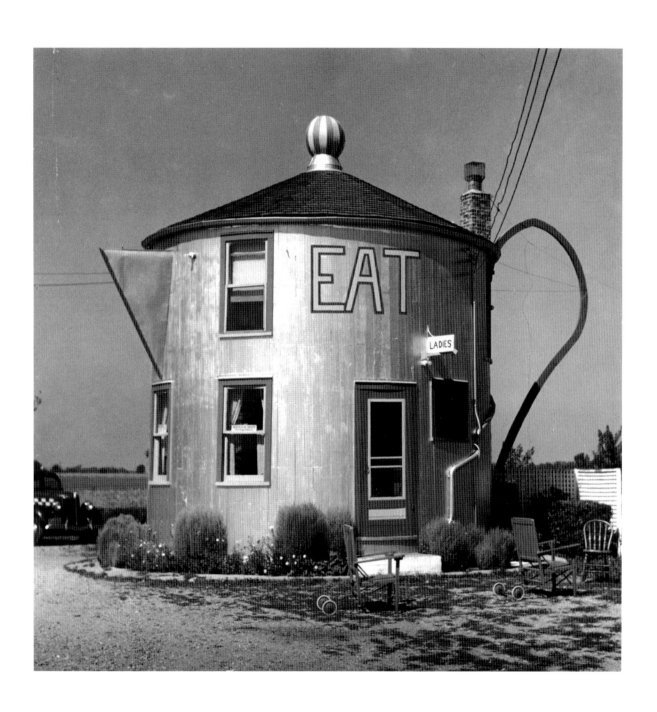

57

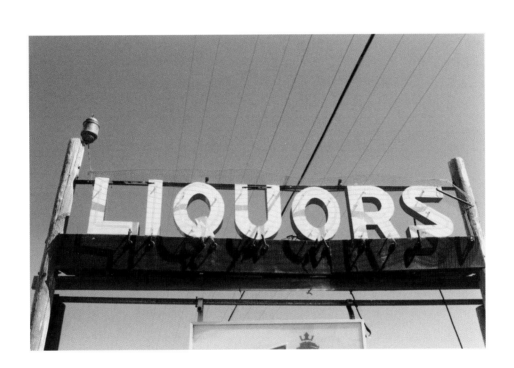

58

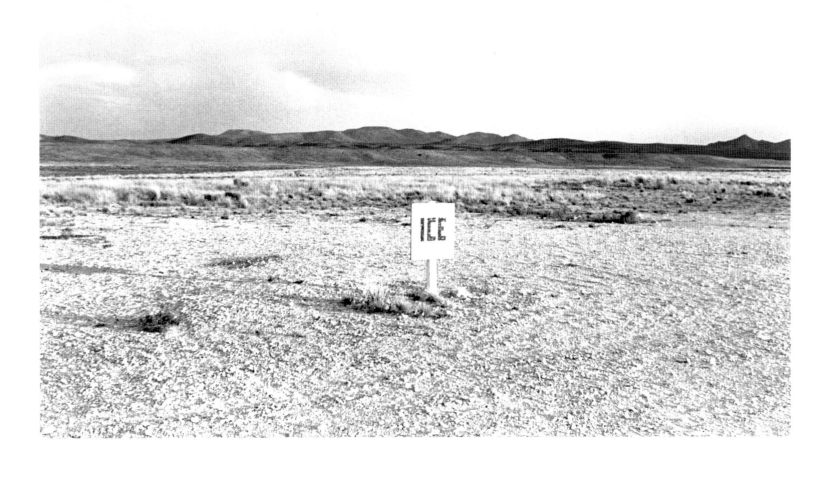

59

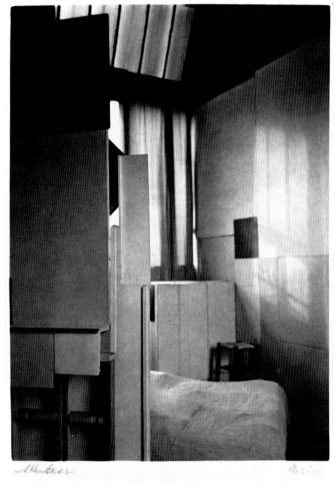

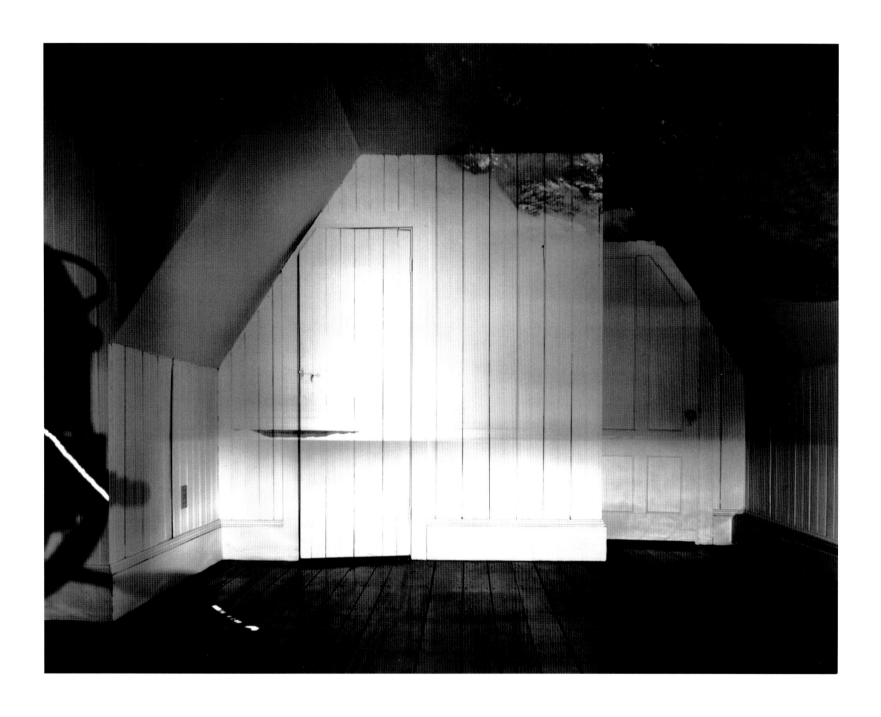

61

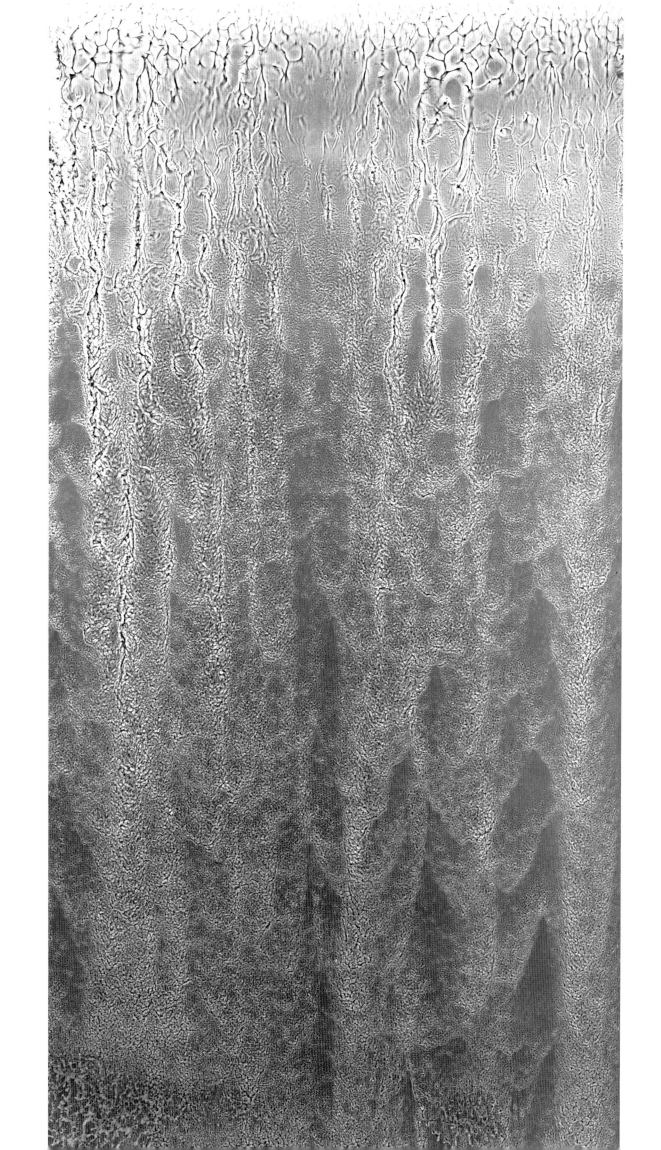

62

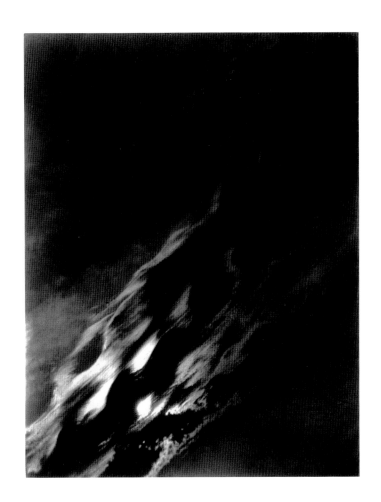

63 *a,b,c*

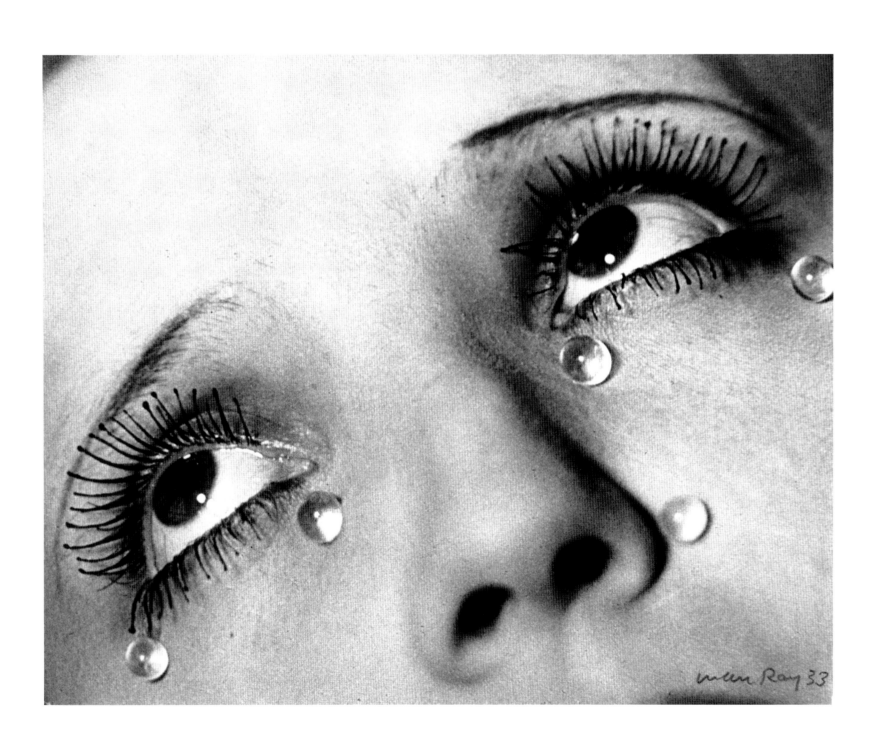

65

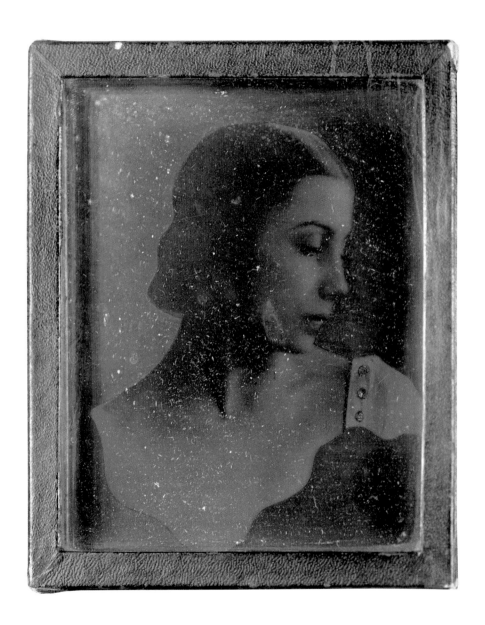

66

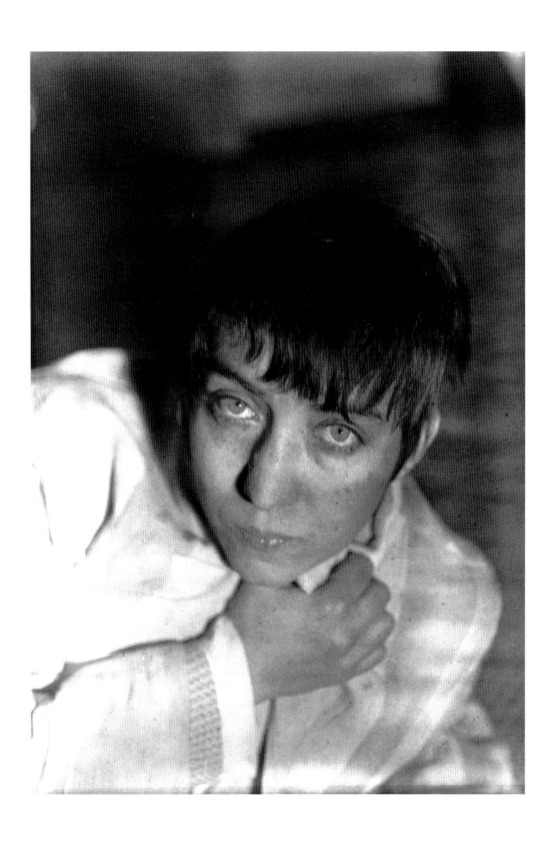

67

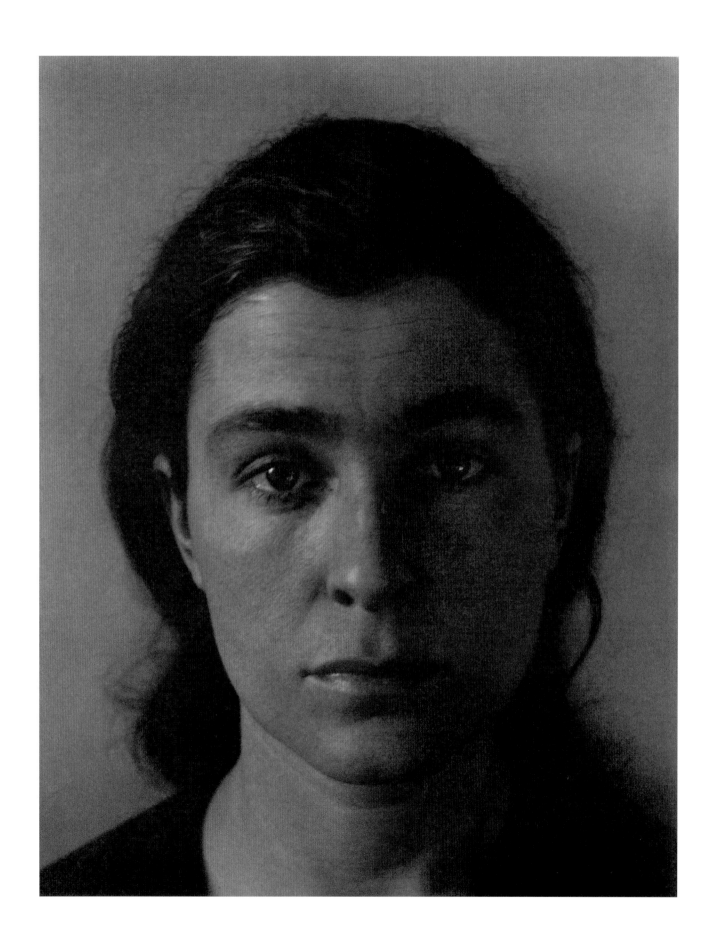

68

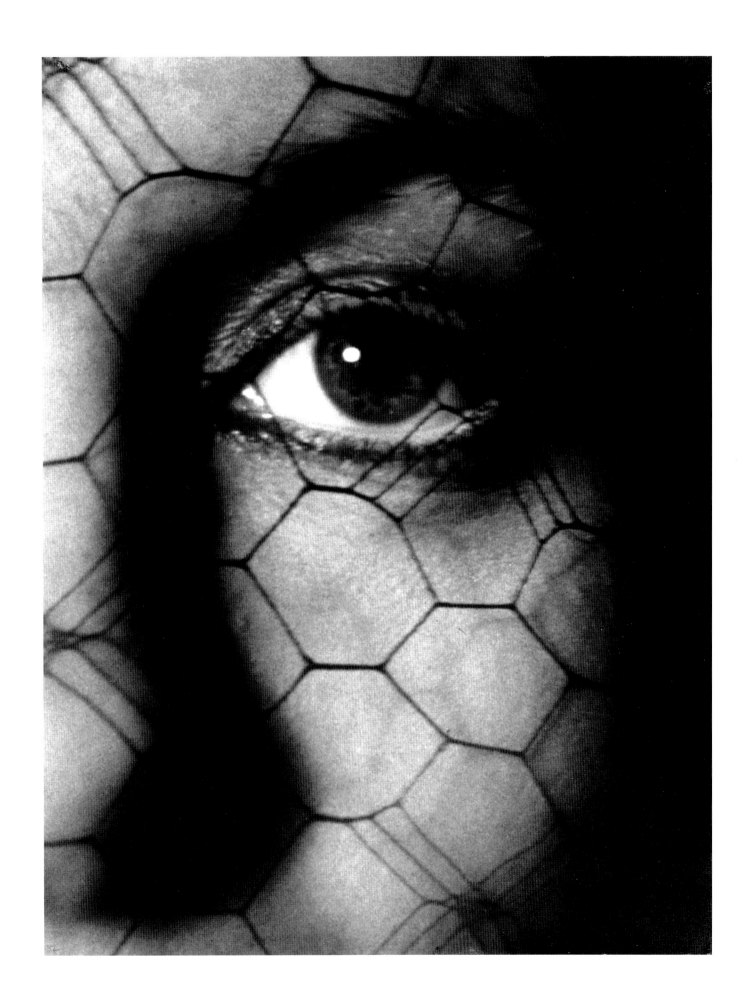

1. **THOMAS EAKINS**
Study for "The Swimming Hole", ca. 1883, platinum print, 8¾ x 11 in.

2. **NICHOLAS NIXON**
Sam, Lexington, 1998, gelatin-silver print, 10 x 8 in.

3. **EDWARD WESTON**
Nude, 1925, platinum print, 8¾ x 7½ in.
Private Collection, Courtesy Houk Gallery

4. **PAUL OUTERBRIDGE**
Untitled, 1924, platinum print, 4¾ x 3⅝ in.

5. **LEWIS CARROLL**
Xie Kitchin, ca. 1875, albumen print, 4⅜ x 6⅝ in.

6. **E. J. BELLOCQ**
Untitled (Storyville Portrait), ca. 1912, printing-out paper, 8 x 10 in.

7. **ALEKSANDR RODCHENKO**
Morning Wash (Utrennii tualet [Varvara Rodchenko]), 1932, gelatin-silver print, 7 x 5 in.

8. **ATTRIBUTED TO**
CONSTANT ALEXANDRE FAMIN
Untitled (River Landscape in Autumn), ca. 1875, albumen print, 8⅞ x 7¼ in.

9. **ANNA ATKINS**
Bromus Tectorum, ca. 1850, cyanotype, 10¼ x 8 in.

10. **RALPH STEINER**
Egg Beater Abstraction, 1921–22, gelatin-silver print, 7⅜ x 9½ in.

11. **DAVID SMITH**
Untitled, ca. 1932, gelatin-silver print, 3⅜ x 5 in.

12. **EDWARD STEICHEN**
Aerial Incendiary Bombs, ca. 1918, gelatin-silver print, 15⅜ x 10⅞ in.

13. **TINA MODOTTI**
Telegraph Wires, ca. 1925, platinum print, 9⅜ x 7⅛ in.

14. **THE EARL OF CAITHNESS**
AND MR. BEMBRIDGE
Great Beech on Manor Hill, 1864, albumen print, 11¼ x 9¼ in.

15. **HARRY CALLAHAN**
Telephone Wires, Providence, 1962 (?), gelatin-silver print, 7⅜ x 7½ in.

16. **FLORENCE HENRI**
Self-Portrait, 1928, gelatin-silver print, 15½ x 10 in.

17. **ADAM FUSS**
Self-Portrait, 1998, daguerreotype, 5 x 4 in.

18. **BRASSAÏ**
L'Armoire à Glace, Rue Quincampoix, Paris, ca. 1932, gelatin-silver print, 11¼ x 8¼ in.

19. **IRVING PENN**
Irving Penn Turning Head, New York, 1993, gelatin-silver print, 3½ x 4½ in.

20. **EDWARD RUSCHA**
Swollen Eye (Self-Portrait), 1973, gelatin-silver print, 7¾ x 9½ in.

21. **MARCEL DUCHAMP (WITH MAN RAY)**
Monte Carlo Bond, 1924 [–1941?], gelatin-silver print on bond, 12⅜ x 7¾ in.

22. **ANDY WARHOL**
Untitled (Self-Portrait), 1963–64, gelatin-silver print, 7⅞ x 1⅝ in.

23. **NADAR**
Nadar with His Wife, Ernestine, in a Balloon, ca. 1865, gelatin-silver print, 3⅜ x 3⅛ in.

24. **NAN GOLDIN**
Self-Portrait on the Train, Germany, 1992, dye destruction print, 25¾ x 38½ in.

PLATES

25. **PHOTOGRAPHER UNKNOWN**
Rogues Gallery: Emotional Moments, Remarkable Dramatics and Facial Contortionisms, ca. 1940, nine gelatin-silver prints, 2¼ x 1⅞ in. (each)

26. **CLAUDE CAHUN**
Self-Portrait, ca. 1928, gelatin-silver print, 4¾ x 3½ in.

27. **PIERRE-LOUIS PIERSON**
La Comtesse de Castiglione, 1860–63/printed ca. 1890, gelatin-silver print, 11¾ x 15⅝ in.

28. **PHOTOGRAPHER UNKNOWN**
Untitled (Moon Landing on Television), ca. 1969, gelatin-silver print, 3 x 4½ in.

29. **HANS BELLMER**
La Maitrailleuse en État de Grâce/Objet Articulé, 1937, three hand-colored gelatin-silver prints overpainted with white gouache, a. 9 x 9⅛ in. (image), b. 8¼ x 8¼ in. (image), c. 9 x 9⅛ in. (image)

30. **JOEL-PETER WITKIN**
Anna Akhmatova, 1998, gelatin-silver print, 13¼ x 16¾ in.

31. **PHOTOGRAPHER UNKNOWN**
Untitled (Study of Hands), ca. 1865, albumen print, 5½ x 7⅞ in.

32. **ETIENNE-JULES MAREY**
Movements of a Skate's Fins, 1892, gelatin-silver print, 10 x 8 in.

33. **J. JOHN PRIOLA**
Butterflies, 1997, gelatin-silver print, 44½ x 35½ in.

34. **ROUËT**
Comparaison des Membres Déduite de la Torsion de l'Humérus, 1857, albumen print, 4¾ x 5½ in.

35. **CONSTANTIN BRANCUSI**
Still Life (Orchid), ca. 1925, gelatin-silver print, 11¾ x 9⅜ in.

36. **RICHARD MISRACH**
Brick Building, Utah, 1991, chromogenic color print, 30 x 40 in.

37. **HENRI CARTIER-BRESSON**
Ile de la Cité, Paris, 1952, gelatin-silver print, 7⅞ x 11⅞ in.

38. **LOUIS DE CLERCQ**
Baalbeck (Héliopolis), Reste du Temple du Soleil, ca. 1859, albumen print, 8⅛ x 11 in.

39. **DARIUS KINSEY**
Untitled (Man atop Tree Trunk), ca. 1915, gelatin-silver print, 13 x 10⅛ in.

40. **MARK KLETT**
Entering a Narrow Cave, Salt Creek, Utah, 1990, gelatin-silver print, 20 x 16 in.

41. **CHARLES CLIFFORD**
Monserrat, Antiguo Claustro Gótico, ca. 1859, albumen silver print, 16½ x 12⅜ in.

42. **CARLETON E. WATKINS**
The Domes, from Sentinel Dome, Yosemite, ca. 1865–66, albumen print, 15½ x 20½ in.

43. **AUGUSTE-ROSALIE BISSON**
The Ascent of Mont Blanc, 1861, albumen print, 15⅝ x 9¼ in.

44. **FRANCIS FRITH**
The Pyramids of Dahshoor, from the South West, 1858, albumen print, 14¾ x 19 in.

45. **BERND & HILLA BECHER**
Slated Houses, Siegen Area, 1998, fifteen gelatin-silver prints, 62¼ x 92¼ in. (overall)

46. **SOL LEWITT**
Brick Wall #1, 1977, gelatin-silver print, 10¾ x 8¼ in.

47. **EUGÈNE ATGET**
Boutique aux Halles, 1925, printing-out paper, 7 x 9 in.

48. **GARRY WINOGRAND**
Coney Island, New York, ca. 1960, gelatin-silver print, 8⅝ x 12⅞ in.

49. **DIANE ARBUS**
Albino Sword Swallower at a Carnival, MD,
1970, gelatin-silver print, 10¼ x 10 in.

50. **HELEN LEVITT**
New York, ca. 1939, gelatin-silver print,
9⅜ x 4⅜ in.

51. **ROBERT FRANK**
New York City, 1947, gelatin-silver print,
10 x 13½ in.

52. **LEE FRIEDLANDER**
Nashville, 1963, two gelatin-silver prints,
9⅝ x 6⅜ in. (each)

53. **LEON LEVINSTEIN**
Untitled, ca. 1950, gelatin-silver print,
11¾ x 8 in.

54. **WEEGEE**
Woman Cab Driver and Macy's Clown,
ca. 1942, gelatin-silver print, 10½ x 13¼ in.

55. **ROBERT ADAMS**
Pikes Peak, Colorado Springs, 1969,
gelatin-silver print, 5¾ x 5⅞ in.

56. **FRANK NAVARA**
Coffee Pot, Ohio, 1939, gelatin-silver print,
10⅜ x 10⅛ in.

57. **WILLIAM EGGLESTON**
Untitled (Liquor Sign), ca. 1972, chromogenic
color print, 3⅛ x 4⅝ in.

58. **HENRY WESSEL**
Walapai, Arizona, 1971, gelatin-silver print,
8 x 11¾ in.

59. **ANDRÉ KERTÉSZ**
Atelier Mondrian, 1926, gelatin-silver print
on carte postale, 4¼ x 3⅛ in.

60. **ABELARDO MORELL**
Camera Obscura Image of the Sea in Attic,
1994, gelatin-silver print, 18 x 22⅜ in.

61. **SUSAN DERGES**
Waterfall No. 1, 11 March 1998, gelatin-silver
print, 81 x 42 in.

62. **ALFRED STIEGLITZ**
Equivalent, 1931, gelatin-silver print,
4¾ x 3¾ in.

63. **HIROSHI SUGIMOTO**
Tyrrhenian Sea, Mount Polo, 1993, three
gelatin-silver prints, 16⅝ x 21⅜ in. (each)

64. **MAN RAY**
Glass Tears, 1933, gelatin-silver print,
9½ x 11¼ in.

65. **JOSEPH CORNELL**
Tamara Toumanova (Daguerreotype-Object),
1941, construction with photograph, mirror
and rhinestones, 5⅛ x 4⅛ x 7/8 in.

66. **WALKER EVANS**
Berenice Abbott, ca. 1930, gelatin-silver print,
6½ x 4⅝ in.

67. **PAUL STRAND**
Rebecca Salsbury, New York, ca. 1920, plat-
inum (or gelatin-silver?) print, 9⅝ x 7⅝ in.

68. **JOHN GUTMANN**
Memory, 1939, gelatin-silver print, 9⅝ x 7⅝ in.
Collection San Francisco Museum of Modern Art

1979–1980

CARLETON WATKINS
Photographs of the Pacific Coast
September 11–October 20

LEE FRIEDLANDER
October 24–December 1

NASA
Lunar Photographs (1969–1972)
and
LOEWY ET PUISEUX
Photographies Lunaires (1894–1904)
December 5–January 5

TIMOTHY O'SULLIVAN
January 9–February 16

ROBERT ADAMS
From the Missouri West
February 20–March 29

JOHN GUTMANN
April 2–May 3

NICHOLAS NIXON
and
WILLIAM EGGLESTON
Election Eve
May 7–June 14

GEORGE BARNARD
Photographic Views of Sherman's Campaign
June 18–July 26

LEW THOMAS
July 30–August 30

1980–1981

PHOTOGRAPHY AND ARCHITECTURE
September 9–October 4

DIANE ARBUS
Unpublished Photographs
October 8–November 14

GARRY WINOGRAND
Retrospective
November 20–January 3

GERMANY: THE NEW VISION
Photographs of the 1920s and 1930s
January 7–February 14

HENRY WESSEL, JR.
February 18–March 28

EADWEARD MUYBRIDGE
April 1–May 9

TIMO PAJUNEN
May 12–June 13

WALKER EVANS AND ROBERT FRANK
An Essay on Influence
June 17–July 25

ROBERT FRANK FORWARD
*Works by Diane Arbus, William Eggleston,
Robert Frank, Lee Friedlander, Garry
Winogrand, and others*
July 28–September 5

1981–1982

PAUL STRAND
Vintage Photographs (1915–1974)
September 16–October 24

ROBERT MAPPLETHORPE
October 28–December 5

STEPHEN SHORE
December 9–January 16

BILL DANE
January 20–February 27

WALKER EVANS: MANY ARE CALLED
Photographs Made in New York City Subways
March 2–April 3

NICHOLAS NIXON
April 7–May 15

EXHIBITIONS

TIMOTHY O'SULLIVAN AND WILLIAM BELL
The Wheeler Survey (1871–1874)
May 19–June 26

**AUGUST SANDER, LISETTE MODEL,
AND DIANE ARBUS**
June 30–August 28

1982–1983

WILLIAM WEGMAN
September 8–October 16

HELEN LEVITT
October 20–November 27

LEO RUBINFIEN
December 1–December 31

JIM DOW
American Ballparks
and
JOHN GUTMANN
Ten Photographs
January 4–January 29

LEE FRIEDLANDER
Portraits (1958–1980)
February 1–March 5

BRUCE CONNER
Angels (1973–1975)
March 8–April 16

GARRY WINOGRAND
Fifteen Big Shots (1960–1980)
and
WILLIAM EGGLESTON
Recent Color Photographs
April 20–June 4

EADWEARD MUYBRIDGE
Recent Acquisitions
June 8–July 16

ANDY WARHOL
Electric Chairs
and
JOEL-PETER WITKIN
July 20–August 27

1983–1984

FREDERICK SOMMER
and
FAUREST DAVIS
September 8–October 15

JOHN GUTMANN
Women
October 20–November 26

**AMERICAN LANDSCAPE PHOTOGRAPHS
OF THE NINETEENTH CENTURY**
November 30–December 30

**PHOTOGRAPHY IN SPAIN IN THE
NINETEENTH CENTURY**
January 4–February 11

HOLLYWOOD STILL LIFES
February 14–March 24

BILL DANE
March 28–April 28

NICHOLAS NIXON
May 2–June 9

JACQUES-HENRI LARTIGUE
June 13–July 21

DAVID HOCKNEY
July 25–September 1

1984–1985

FIFTH ANNIVERSARY EXHIBITION
September 12–October 13

JOEL-PETER WITKIN
October 17–November 24

MARK KLETT
Searching for Artifacts
December 5–January 12

DIANE ARBUS
Portraits on Assignment
January 16–February 23

O. WINSTON LINK
Photographs of the Norfolk and Western Railway
February 27–March 30

ROBERT ADAMS
Summer Nights
April 3–May 11

ROBERT MAPPLETHORPE
Recent Work in Platinum
May 15–June 22

CHUCK CLOSE
Large-Scale Photographs
June 26–July 27

EDOUARD BALDUS
*Chemins de fer de Paris à Lyon
et à la Méditerranée*
July 31–August 31

1985–1986

RICHARD MISRACH
Scenes from the American Desert
September 11–October 19

JOHN GUTMANN
Vintage Photographs
October 23–November 30

PHOTOGRAPHER UNKNOWN
*Thirty-Three Anonymous Photographs
from the 1840s to the Present Day*
December 4–January 4

LEE FRIEDLANDER
Shiloh
January 8–February 6

HELEN LEVITT
Eighteen Color Photographs
February 12–March 22

GARRY WINOGRAND
Little Known Photographs
March 26–April 26

NICHOLAS NIXON
April 30–May 31

LEO RUBINFIEN
June 4–June 28

PIERRE MOLINIER
Sixteen Erotic Photographs (1967–1976)
and
**SEVERAL EXCEPTIONALLY GOOD
RECENTLY ACQUIRED PICTURES**
July 2–August 16

BILL DANE
August 20–September 20

1986–1987

BRUCE CONNER
September 24–October 25

WILLIAM EGGLESTON
October 29–November 29

ANNA ATKINS
Victorian Photograms (circa 1850)
December 3–January 10

DIANE ARBUS
Untitled Photographs (1970–1971)
January 14–February 28

THE INSISTENT OBJECT
Photographs 1845–1986
March 4–April 18

RICHARD MISRACH
April 22–May 23

ROBERT MAPPLETHORPE
May 27–July 3

LEON BORENSZTEIN
and
**SEVERAL EXCEPTIONALLY GOOD
RECENTLY ACQUIRED PICTURES II**
July 8–September 5

1987–1988

JOEL-PETER WITKIN
September 9–October 17

MARK KLETT
October 21–November 28

DIANE ARBUS
Couples
December 2–January 9

LEE FRIEDLANDER
Little Known Photographs
January 13–February 20

EIGHT PICTURES
*Works by Agnes Martin, Ad Reinhardt,
Paul Strand, Edward Weston, and others*
February 24–March 26

JOHN GUTMANN
Talking Pictures: Signs, Graffiti and Tattoos
March 30–May 6

QUEER LANDSCAPES
and
O. WINSTON LINK
Vintage Photographs
May 11–June 18

STERN J. BRAMSON
and
**SEVERAL EXCEPTIONALLY GOOD
RECENTLY ACQUIRED PICTURES III**
June 22–July 30

WILLIAM WEGMAN
August 3–September 17

1988–1989

NICHOLAS NIXON
People with AIDS
September 21–October 20

ROBERT ADAMS
Perfect Times, Perfect Places
October 25–November 26

GARRY WINOGRAND
November 30–January 14

ROBERT MAPPLETHORPE
January 18–February 25

DIANE ARBUS
Nineteen Faces
March 1–April 8

RICHARD MISRACH
The Pit
April 12–May 12

CARLETON WATKINS
Part I: Yosemite and the Mariposa Grove
May 17–June 24

CARLETON WATKINS
*Part II: The Pacific Coast and Mining Views,
The Columbia River and Oregon, and Utah*
June 28–August 5

CATHERINE WAGNER
and
**SEVERAL EXCEPTIONALLY GOOD
RECENTLY ACQUIRED PICTURES IV**
August 9–September 9

1989–1990

EADWEARD MUYBRIDGE
Panorama of San Francisco (1878)
September 13–October 21

HENRY WESSEL
Still Photographs
October 25–December 2

GARRY WINOGRAND
The Animals
December 6–January 13

HELEN LEVITT
Little Known Photographs
January 31–March 10

THE INDOMITABLE SPIRIT
Works by John Baldessari, Chuck Close,
Cindy Sherman, William Wegman, and others
March 14–April 14

MARK KLETT
April 18–May 26

MCDERMOTT & MCGOUGH
May 30–July 7

LEE FRIEDLANDER
A Small Selection of Large Prints
and
SEVERAL EXCEPTIONALLY GOOD
RECENTLY ACQUIRED PICTURES V
July 19–August 31

1990–1991
IRVING PENN
14 Cigarettes
September 5–October 20

WILLIAM WEGMAN
and
MARK KLETT
Panorama of San Francisco
from California Street Hill
October 24–December 1

RICHARD MISRACH
The Playboys
December 5–January 12

NICHOLAS NIXON
Family Pictures
January 16–February 9

THE KISS OF APOLLO
Photography & Sculpture: 1845 to the Present
February 14–March 30

JOEL-PETER WITKIN
April 3–May 25

OCTOBER 1989 EARTHQUAKE NECESSITATES THAT THE
GALLERY RELOCATE TO 49 GEARY STREET, JUNE 1.

SELECTIONS
June 18–July 6

BERND & HILLA BECHER
July 11–September 7

1991–1992
LOUIS-EMILE DURANDELLE
Le Nouvel Opéra de Paris (1865–1872)
and
JOHN GUTMANN
The Real Small Picture
September 12–October 19

DIANE ARBUS
and
IN A DREAM
A portfolio by Photographers + Friends
United Against AIDS
October 24–November 30

IRVING PENN
Portraits in a Corner (1948)
December 5–January 11

MCDERMOTT & MCGOUGH
January 16–February 22

HENRY WESSEL
House Pictures
February 26–March 28

HIROSHI SUGIMOTO
and
JAY DEFEO
Photocollages
April 2–May 9

WILLIAM WEGMAN
May 13–June 20

ADAM FUSS
June 24–August 1

SEVERAL EXCEPTIONALLY GOOD
RECENTLY ACQUIRED PICTURES VI
August 5–September 12

1992–1993

BILL DANE'S HISTORY
OF THE UNIVERSE
September 17–October 17

GILBERT & GEORGE
Post-Card Sculptures
October 21–November 28

THE LARGER VIEW
19th Century American
Mammoth-Plate Photographs
and
NICHOLAS NIXON
Pictures from Perkins School for the Blind
December 2–December 31

RICHARD MISRACH
Clouds
and
THE EARL OF CAITHNESS
& MR. BEMBRIDGE
The Trees of Windsor Great Park
and Windsor Forest (1864)
January 6–February 13

LARRY CLARK
February 18–March 27

JOEL-PETER WITKIN
April 1–May 15

BERND & HILLA BECHER
May 20–July 2

JAN GROOVER
and
SEVERAL EXCEPTIONALLY GOOD
RECENTLY ACQUIRED PICTURES VII
July 8–August 21

1993–1994

CATHERINE WAGNER
Home and Other Stories
and
FELIX TEYNARD
Calotypes of Egypt (1851–1852)
August 26–September 25

EDWARD WESTON
September 29–November 13

WILLIAM WEGMAN
and
VICTORIAN SECRETS
Anonymous Photo-Collages
from the 19th Century
and
ANDREW BUSH
Envelopes
November 18–December 30

ADAM FUSS
and
ROBERT ADAMS
Vintage Prints (1968–1974)
January 6–February 5

HIROSHI SUGIMOTO
February 10–March 19

LEE FRIEDLANDER
Letters from the People
and
HELEN LEVITT
In the Street
March 23–May 7

SOPHIE CALLE
May 12–July 1

J. JOHN PRIOLA
and
SEVERAL EXCEPTIONALLY GOOD
RECENTLY ACQUIRED PICTURES VIII
July 7–September 3

1994–1995

GARRY WINOGRAND
The Sixties
September 14–November 5

NAN GOLDIN
November 9–December 30

SEEING THINGS
Fifteenth Anniversary Exhibition
January 5–February 4

HIROSHI SUGIMOTO
Still Life
and
LEE FRIEDLANDER
The Little Screens
February 9–March 25

NICHOLAS NIXON
Portraits (1975–1995)
and
JOHN GUTMANN
Death
March 30–April 29

JOEL-PETER WITKIN
May 4–June 30

SEVERAL EXCEPTIONALLY GOOD
RECENTLY ACQUIRED PICTURES IX
July 6–September 9

1995–1996

RICHARD MISRACH
and
LARRY CLARK
Untitled (Kids)
September 14–October 21

CHRISTOPHER BUCKLOW
Guest
October 26–December 2

ROBERT ADAMS
West from the Columbia
and
CARLETON WATKINS
Recent Acquisitions
December 7–January 13

THOMAS RUFF
January 18–March 2

HIROSHI SUGIMOTO
Twenty-One Seas (1980–1995)
March 7–April 27

BERND & HILLA BECHER
May 2–June 29

ABELARDO MORELL
Books and Other Pictures
and
SEVERAL EXCEPTIONALLY GOOD
RECENTLY ACQUIRED PICTURES X
July 9–September 7

1996–1997

LEE FRIEDLANDER
The Desert Seen
and
E. J. BELLOCQ
Photographs from Storyville
September 12–October 19

CATHERINE WAGNER
Art & Science: Investigating Matter
October 24–November 30

UNDER THE SUN
Photographs by Christopher Bucklow, Susan Derges, Garry Fabian Miller, and Adam Fuss
December 5–January 11

OPEN SECRETS
Seventy Pictures on Paper: 1815 to the Present
January 16–March 1

NAN GOLDIN
and
J. JOHN PRIOLA
Saved
March 6–April 26

WILLIAM WEGMAN
and
RICHARD MISRACH
May 1–June 28

SEVERAL EXCEPTIONALLY GOOD
RECENTLY ACQUIRED PICTURES XI
July 2–August 29

1997–1998

JOEL-PETER WITKIN
and
FRANCIS FRITH
Egypt, Sinai, & Jerusalem (1858)
September 4–October 11

ROBERT ADAMS
What We Bought: The New World (1970–1974)
October 16–November 22

IRVING PENN
The Small Trades (1950)
and
NICHOLAS NIXON
Bebe & Me
November 26–December 24

SOL LEWITT
Wall Drawings and Photographs (1969–1998)
January 7–February 28

HIROSHI SUGIMOTO
and
AGNES MARTIN
March 5–April 25

DAVID SMITH
Photographs (1931–1965)
April 30–June 6

LEE FRIEDLANDER
Self Portrait
June 10–July 18

**SEVERAL EXCEPTIONALLY GOOD
RECENTLY ACQUIRED PICTURES XII**
July 23–September 5

1998–1999

DUST BREEDING
Photographs, Sculpture & Film
Works by Diane Arbus, Marcel Duchamp,
Robert Gober, László Moholy-Nagy, Cindy
Sherman, Rachel Whiteread, and others
September 10–October 31

ADAM FUSS
and
EUGÈNE ATGET
November 5–December 30

GARRY WINOGRAND
The Man in the Crowd
January 7–February 27

RICHARD MISRACH
Golden Gate
March 4–April 10

SUSAN DERGES
Woman Thinking River
April 15–May 29

GEORGE ROBINSON FARDON
San Francisco Album (1854–1856)
June 3–August 14

20TWENTY
Twentieth Anniversary Exhibition
September 9–November 27

BOOKS

20TWENTY, 1999

SAN FRANCISCO ALBUM: GEORGE ROBINSON FARDON, PHOTOGRAPHS 1854–1856
essays by Peter E. Palmquist, Rodger C. Birt and Joan M. Schwartz, catalogue raisonné by Marvin Nathan,
in association with Hans P. Kraus, Jr., Inc., 1999

SUSAN DERGES: WOMAN THINKING RIVER, introduction by Mark Haworth-Booth,
essay by Charlotte Cotton, in association with Danziger Gallery, 1999

THE MAN IN THE CROWD: THE UNEASY STREETS OF GARRY WINOGRAND
introduction by Fran Lebowitz, essay by Ben Lifson, in association with D.A.P., 1999

DUST BREEDING: PHOTOGRAPHS, SCULPTURE & FILM, introduction by Steve Wolfe, 1998

LEE FRIEDLANDER: SELF PORTRAIT, afterword by John Szarkowski, in association with D.A.P., 1998

DAVID SMITH: PHOTOGRAPHS 1931–1965
introduction by Rosalind E. Krauss, essay by Joan Pachner, in association with Matthew Marks Gallery, 1998

OPEN SECRETS: SEVENTY PICTURES ON PAPER—1815 TO THE PRESENT
in association with Matthew Marks Gallery, 1996

**UNDER THE SUN: PHOTOGRAPHS BY CHRISTOPHER BUCKLOW, SUSAN DERGES,
GARRY FABIAN MILLER, AND ADAM FUSS**, essay by David Alan Mellor, 1996

SEEING THINGS, 1995

HENRY WESSEL: HOUSE PICTURES, 1992

BILL DANE'S HISTORY OF THE UNIVERSE, 1992

THE KISS OF APOLLO: PHOTOGRAPHY AND SCULPTURE—1845 TO THE PRESENT
essay by Eugenia Parry Janis, 1991

CARLETON E. WATKINS: PHOTOGRAPHS 1861–1874, essay by Peter E. Palmquist, 1989

THE INSISTENT OBJECT: PHOTOGRAPHS 1845–1986, 1987

PHOTOGRAPHY IN SPAIN IN THE NINETEENTH CENTURY
text by Lee Fontanella, in association with Delahunty Gallery, 1983

PUBLICATIONS

MARK KLETT: PANORAMA OF SAN FRANCISCO FROM CALIFORNIA STREET HILL

Thirteen 20 x 16 inch gelatin-silver prints in a cloth case with colophon, edition of fifty, 1990

BILL DANE: LITTLE KNOWN

Eleven 8 x 10 inch chromogenic-color prints mounted on Rives paper and bound in cloth book covers, with removable screws, edition of twelve, 1984

GARRY WINOGRAND: FIFTEEN BIG SHOTS

Fifteen 16 x 20 inch gelatin-silver prints in a cloth case with colophon, edition of twenty-nine (proposed edition of one hundred was not completed due to the artist's death), 1984

JOHN GUTMANN: TEN PHOTOGRAPHS

Ten matted 14 x 17 inch gelatin-silver prints in a cloth case with colophon, edition of fifty, 1982

It works like this: sometimes certain people have a particular sense or a special understanding about aspects of the world. Sometimes these people are adept with a camera or other photographic materials, and are able to transcribe onto paper their slices of comprehension through the medium of photography. Because making a photograph is a relatively easy matter, countless numbers have been produced since the medium's invention sixteen decades ago ("more photographs than bricks" wrote John Szarkowski in 1983). But for the same reasons that skills as a house painter are no guarantee of an ability to create a painting of significance, it is equally improbable that the everyday photographer will make a photograph of lasting qualities beyond the sentimental. There are stunning exceptions of course, yet the sheer quantity of photographs made every minute stacks high odds against any single picture distinguishing itself from the world's enormous trash pile of imagery. The fact remains, however, that there *are* certain people who, by using photography's particular manner of describing things, convey their perceptions so compellingly that we return to their photographs again and again. In a loose sense, these are the photographs the gallery has attempted to focus on since opening twenty years ago.

AFTERWORD

Twenty years after, as much as twenty years after in as much as twenty years after, after twenty years and so on. It is it is it is it is.

Keep it in sight all right.

GERTRUDE STEIN, FROM "VAN OR TWENTY YEARS AFTER"

Watkins, Friedlander, and NASA's lunar photographs were the gallery's first three exhibitions and set a tone and pattern for what followed. Photography's brief history lends itself to examination backward, forward, and sideways in time, and the canon has not been so solidly engraved that eccentric or unexpected applications can be entirely discounted. The very notion of a canon at all may seem slightly at odds with the medium's nature. Nonetheless the armature of the gallery's program was set with Atget, Evans, Weston, and Arbus, who were shown early on and repeatedly (if not in solo exhibitions then often in "the second gallery") interspersed with more speculative exhibitions such as *The Insistent Object, Queer Landscapes,* and *Photographer Unknown.*

The second decade—demarcated from the first by an earthquake, literally—brought exhibitions of the Bechers, Adam Fuss, Hiroshi Sugimoto, and Sol LeWitt, along with the challenge of coming to terms with photography's status separate and apart from other works of art. That photography has had a profound effect on all the visual arts, and vice versa, is an indisputable fact which has become so thoroughly a part of our understanding that the idea of "photography department," or "photography gallery," seems vaguely archaic. Museums have visibly acknowledged this by integrating photographs among paintings, drawings, and sculpture with ever increasing frequency. It has been difficult for the gallery to resist what seems a natural evolution without periodi-

cally exhibiting works by artists such as Joseph Cornell, David Smith, Agnes Martin, or Andy Warhol. Their works speak to the photographs, and vice versa. In short, everything connects.

As far as what the coming decade will bring, predictions would only be foolish, impossible, and wrong. Still, one bet may be worth making. With the rapidly diminishing quantity of silver in photographic papers, and the dizzying inundation of electronic virtual images in our lives, the object we experience as "a photograph" (in the twentieth century sense, typically a sheet of good quality paper with a coating of silver suspended in gelatin) may start to seem antique. But photography is an art unlike any other. It has a peculiar, insoluble connection to the real world. Even after a century of spirited dissection it retains the capacity to mesmerize. We continue to be drawn to photographs because they can tell us interesting things about life. At the gallery, it's why we do what we do.

Jeffrey Fraenkel

INDEX

ACKNOWLEDGMENTS

DOON ARBUS

ADAM BOXER

GABRIEL CATONE

JIM CORCORAN

CARLA EMIL

BOB FISHER

SUSAN FRIEDEWALD

TAMARA FREEDMAN

SARAH GREENOUGH

MARIA MORRIS HAMBOURG

EDWYNN HOUK

CHARLES ISAACS

HANS P. KRAUS, JR.

JAN LEONARD

PETER MACGILL

ALAN MARK

DOUGLAS R. NICKEL

PAGE IMAGEWORKS

DEXTER PAINE

SUSAN PAINE

JEFFREY PEABODY

JERROLD PEIL

SANDRA S. PHILLIPS

OLIVIER RENAUD-CLEMENT

JEFF ROSENHEIM

ANDREW RUTH

RICH SILVERSTEIN

GARY SOKOL

PETER STEVENS

JOHN SZARKOWSKI

THOMAS WALTHER

THEA WESTREICH

HELEN WRIGHT

JASON YSENBURG

MARY ZLOT

and Harry Lunn

Aside from those works in the public domain, nearly all the images reproduced in this volume are copyrighted by their makers, or by the respective families, estates, foundations, or representatives of the artists. Every effort was made to contact all such parties to obtain official permission to reproduce, and we are very grateful for the kind cooperation extended by the artists included in this book, or by their families, estates, foundations, or representatives. In some cases, their permission to reproduce was conditioned upon the publication of a credit line or notice of copyright. These are as follows:

Diane Arbus (plate 49) ©1972 The Estate of Diane Arbus; Brassaï (plate 18) ©Gilberte Brassaï; Joseph Cornell (plate 65) ©The Joseph and Robert Cornell Memorial Foundation; Marcel Duchamp (plate 21) ©1999 Artists Rights Society, New York/ADAGP, Paris/Estate of Marcel Duchamp; Walker Evans (plate 66) ©Walker Evans Archive, The Metropolitan Museum of Art, New York; André Kertész (plate 59) ©Estate of André Kertész; Leon Levinstein (plate 53) ©Stuart Karu, Courtesy Howard Greenberg Gallery; Man Ray (plate 64) ©1999 Man Ray Trust/Artists Rights Society, New York/ADAGP, Paris; Irving Penn (plate 19) ©1996 by Irving Penn; David Smith (plate 11) ©1998 Estate of David Smith/Licensed by VAGA, New York, NY; Paul Strand (plate 67) ©1990, Aperture Foundation Inc., Paul Strand Archive; Andy Warhol (plate 22) ©Andy Warhol Foundation for the Visual Arts/ARS, New York; Edward Weston (plate 3) ©1981 Center for Creative Photography, Arizona Board of Regents.

Front cover
Man Ray, *Glass Tears,* 1933
(detail, plate 64)

Back cover
John Gutmann, *Memory,* 1939
(detail, plate 68)

Editor
Jeffrey Fraenkel

Project Advisor
Frish Brandt

Project Coordinators
Dalia Azim
Debbie Berne
Brandon Moyer
Spencer Rank
Lizanne Suter
Dawn Troy
Ken Turner
Amy R. Whiteside

Design
Catherine Mills Design, Seattle

Copy Photography
Ian Reeves Photography, San Francisco

Printing Supervision
Sue Medlicott

Printing
Cantz, Ostfildern, Germany

This book accompanies an exhibition held at Fraenkel Gallery, San Francisco September 9–November 27, 1999.

©1999 Fraenkel Gallery, San Francisco
First Edition
ISBN 1-881337-07-3

Fraenkel Gallery
49 Geary Street
San Francisco, California 94108
telephone 415.981.2661
facsimile 415.981.4014

Distributed by
D.A.P./Distributed Art Publishers
155 Sixth Avenue, Second Floor
New York, New York 10013
telephone 212.627.1999
facsimile 212.627.9484

COLOPHON